LANDSCAPE PAINTING INSIDE & OUT

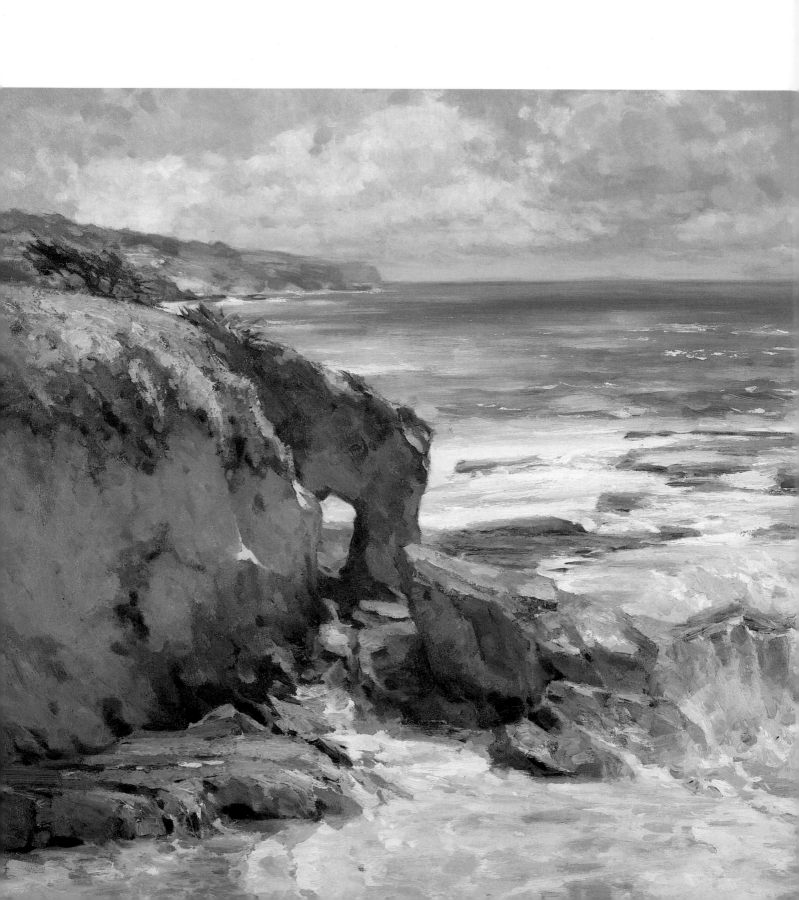

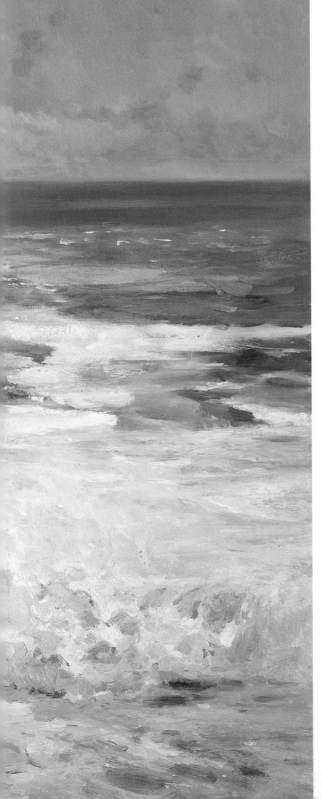

landscape painting

Inside
&Out

Capture the Vitality of
Outdoor Painting in Your
Studio With Oils

Kevin D. Macpherson

NORTH LIGHT BOOKS
CINCINNATI, OHIO
www.artistsnetwork.com

About the Author

Kevin Macpherson is a highly respected oil painter and a sought-after workshop instructor. He is the author of *Fill Your Oil Paintings With Light and Color* (North Light Books, 1997) and *Reflections on a Pond* (Studio Escondido Books, 2005). He is a member and past president of the Plein Air Painters of America. He and his wife, Wanda, can be found traveling the globe in search of stunning vistas to paint. His work can be seen regularly in art magazines such as *The Artist's Magazine, American Artist* and *International Artist*.

DISTRIBUTED IN CANADA BY FRASER DIRECT
100 Armstrong Avenue
Georgetown, ON, Canada L7G 5S4
Tel: (905) 877-4411

DISTRIBUTED IN THE U.K. AND EUROPE BY DAVID & CHARLES
Brunel House, Newton Abbot, Devon, TQ12 4PU, England
Tel: (+44) 1626 323200, Fax: (+44) 1626 323319
Email: postmaster@davidandcharles.co.uk

DISTRIBUTED IN AUSTRALIA BY CAPRICORN LINK
P.O. Box 704, S. Windsor NSW, 2756 Australia
Tel: (02) 4577-3555

Library of Congress Cataloging in Publication Data
Macpherson, Kevin D.
 Landscape painting inside and out : capture the vitality of outdoor painting in your studio with oils / Kevin D. Macpherson.
 p. cm.
 Includes index.
 ISBN-13: 978-1-58180-755-4 (hardcover : alk. paper)
 ISBN-10: 1-58180-755-4 (hardcover : alk. paper)
 1. Plein air painting--Technique. 2. Landscape painting--Technique. I. Title. II. Title: Capture the vitality of outdoor painting in your studio with oils.
 ND1342.M33 2006
 751.4--dc22
 2006013469

Art on p. 6: *Treetop Vista*, 16" × 20" (41cm × 51cm)
Art on p. 7: *Harvest Time*, 6" × 8" (15cm × 20cm)

Editor: Amy Jeynes
Designer: Guy Kelly
Production artist: Sandy Kent
Production coordinator: Jennifer Wagner

Metric Conversion Chart

To convert	to	multiply by
Inches	Centimeters	2.54
Centimeters	Inches	0.4
Pounds	Kilograms	0.45
Kilograms	Pounds	2.2
Ounces	Grams	28.3
Grams	Ounces	0.035

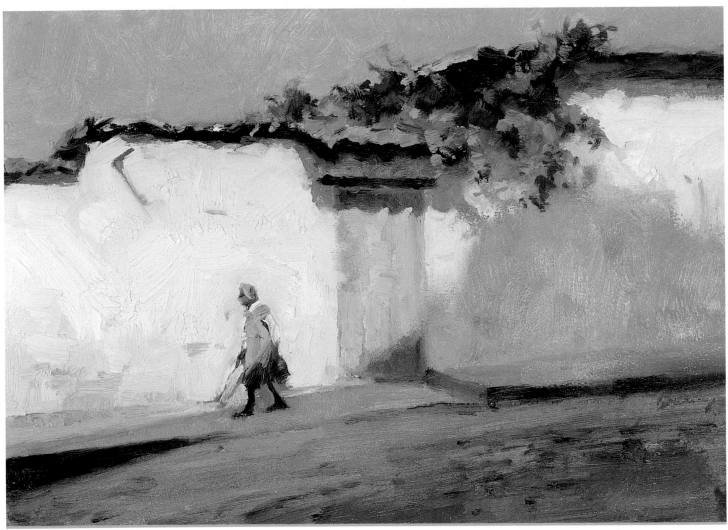

Camino De Vallarta
6" × 8" (15cm × 20cm)

Acknowledgments

The Plein Air Painters of America, founded in 1986, truly inspired a revolution. Artists returned to the outdoors to study nature firsthand. I am grateful to be a participant in this rebirth, and I acknowledge the generosity of all the dedicated fine artists who share this wonderful visual language of representational painting.

Thanks to Dr. Bill Leibow for traveling with me through the medieval villages of Europe and withstanding the cold, snowy conditions in Taos to capture some of my demonstrations on film. Thanks to Rick Raymond for his photos of me in the studio.

Robert Gamblin, America's premiere color man, of Gamblin Artist's Colors, graciously authorized use of Gamblin Art products and gave technical advice on materials.

Editor Amy Jeynes was a pleasure to work with and extremely patient as she waited for bits and pieces of my manuscript to trickle in amid my travels and hectic schedule.

Dedication

Art has blessed my life, and I am fortunate to do what I love alongside my wife, Wanda. We are a wonderful team, and this makes life the best. Sharing life's ups and downs with the one I love and trust gives me freedom to pursue my dreams.

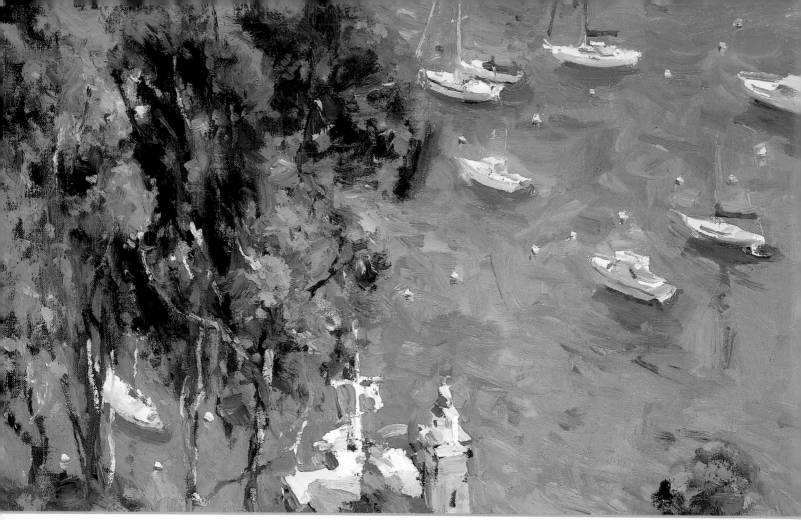

contents

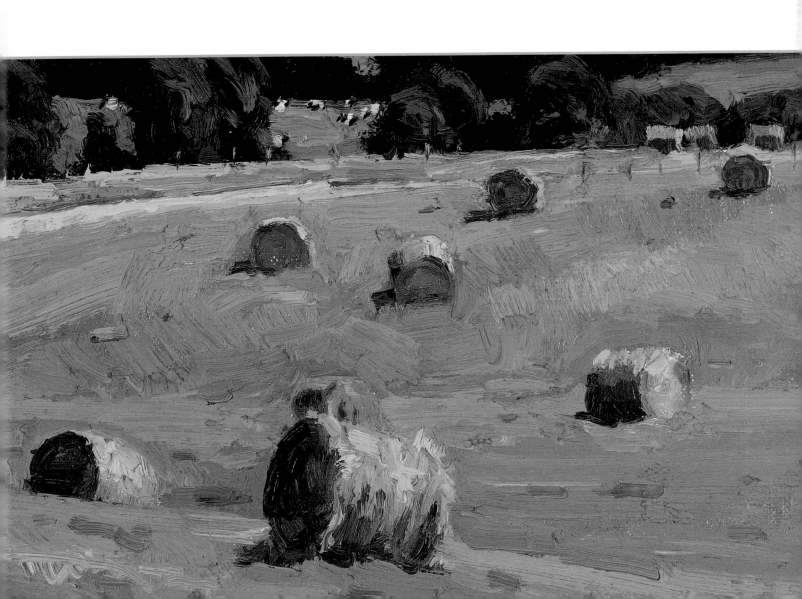

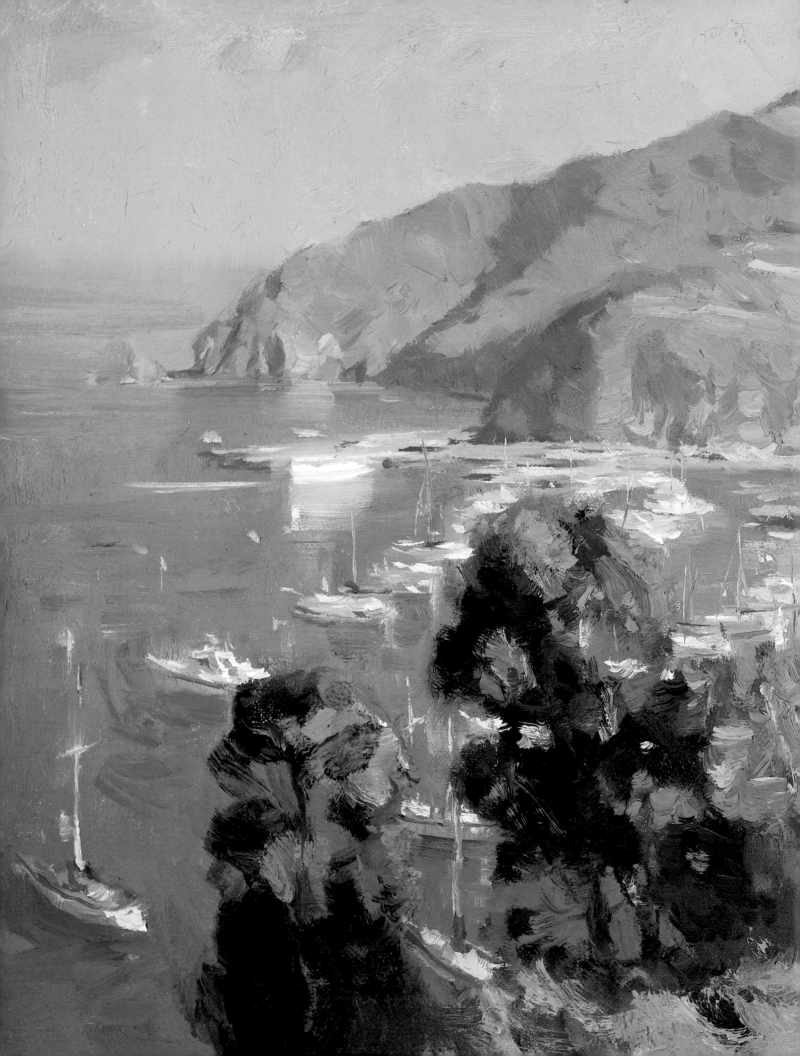

INTRODUCTION

So many people work in arenas that discourage creativity. In fact, society as a whole attempts to persuade us not to consider an independent creative lifestyle as a wise choice. Nevertheless I guarantee that, whatever your chosen field, art will enrich your life.

My first book, *Fill Your Oil Paintings With Light and Color*, has guided many beginning and struggling artists with its simple approach to picture making. For me, seeing the world through the eyes of an artist and sharing the gift of art have been most rewarding.

There is always a learning curve associated with acquiring a new skill, whether it be golf, skiing, painting—or typing, as I'm finding as I write this manuscript. I believe anyone willing to go through the awkward learning curve can obtain the general knowledge necessary to get started creating art. Indeed, mastering any skill sets one up for complacency and a loss of the joy and wonder that enticed one into the field in the first place. So embrace the trials and tribulations of learning to paint. Celebrate your moments of genius, and laugh at the awful stuff that you will sometimes produce. The only things you're using up are paint, canvas and some time—time you're spending enjoying the world around you.

This book will encourage you to let your intuition rule when you paint outdoors. Step-by-step demonstrations and stimulating practice exercises in the studio will prepare you for your adventures outside. You'll learn the power of a limited palette, how to use set palettes, and how color, values, shape and edges can all work together to bring your art to a new level. I encourage you to paint both outdoors and inside. Contemplative study in the solitude of your studio is important to your development into a highly skilled, passionate plein air painter. A balanced approach in which you work both indoors and outdoors will foster your growth as an artist painting with purpose.

When I wrote my first book, the term *en plein air* (French for "in open air") was not used in the mainstream, but today it is a familiar term. Plein air painting basically means painting from life. If an inquisitive artist is prepared to ask the right questions, standing before nature will reveal all the answers. This book will teach you to ask the right questions. It will guide you comfortably through the many challenges that are inherent in plein air painting. You'll learn about the tools and the art principles needed for painting both indoors and out.

The great painters of the past created thoughtful art in their studios with no loss of the vitality and spontaneity we associate with painting outdoors. We will explore ways to relive the outdoor experience, enlarge our ideas and refine our compositions.

The increasing prominence of the plein air school of thought has led some to believe that just because a painting was done outside, it must be good. This is not true. We must be critical of all we produce and set high standards for ourselves regardless of the methods employed. I hope you will always look for new ways to stimulate your senses, continually challenge yourself with new techniques, and keep that curious spirit.

Kevin Macpherson

Great artistic ideas are often lost for want of good drawing skills or effectively related color and value arrangements. Yet a well-executed painting without passion is only an exhibition of technique and craft—not art.

1

THE STUDIO, INSIDE AND OUT

I aim for simplicity in my methods and materials as well as in my paintings. For almost all my oil paintings—whether landscape or figure, painted indoors or out—I use yellow, red, blue and white. Occasionally I use a medium. It does not get much simpler than that.

I recommend that you stick with a simple selection of tools and materials. Get familiar with them so that they become one with your body and mind. Struggling with a profusion of materials will hinder your freedom to create.

Your studio is your research lab. Explore, experiment, innovate. Mix up your routine. Take a chance.

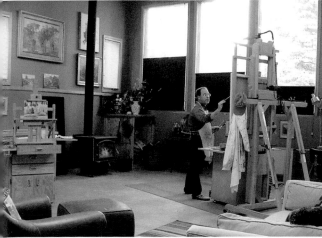

ESSENTIAL BRUSHES

With the brushes shown here, you'll be well equipped for painting indoors and out.

1 Nos. 4, 6, 8 and 10 bristle filberts
2 Nos. 4, 6, 8, 10 and 12 bristle brights
3 Nos. 4, 6 and 8 bristle rounds
4 No. 3 sable round
5 No. 4 sable bright
6 Nos. 8 and 10 sable brights
7 No. 6 sable filbert

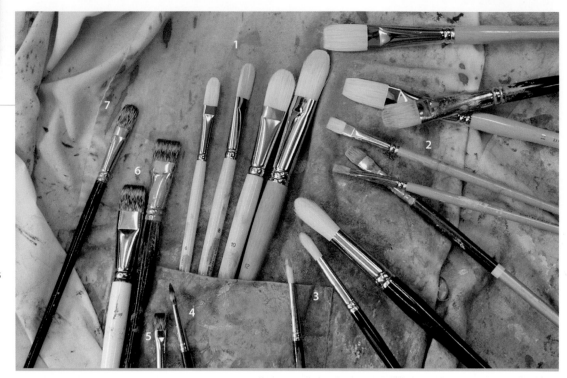

How to Clean Brushes

Pull out excess paint with a tissue or rag. Swirl the brush clean in mineral spirits. Next, wearing rubber gloves, lather the bristles with a bar of hand soap or liquid dish soap and water. Scrub the bristles clean in the palm of your hand. Take care not to soak the wooden handle, but work the paint out of the heel where the bristles meet the metal ferrule.

After cleaning, leave a very slight soap residue on the bristles to help the brush hold its shape. Re-sculpt the shape of the brush with your fingers.

BRUSHES

These are the types of brushes you'll need for painting with oils.

BRIGHTS. The bristles on a bright are square-cut. Brights can hold a hefty amount of paint, like a shovel. However, they may leave a noticeably square stroke.

FILBERTS. Filbert brushes are slightly rounded and can create a variety of strokes. The filbert is the most versatile brush shape.

ROUNDS. These brushes create a calligraphic stroke. Your hand pressure, more than the brush shape itself, influences the character of the stroke.

SABLE BRUSHES. All brush shapes come in sable versions. Have a variety of both sable and bristle brushes. Because sable brushes are softer than bristle brushes, they leave a smoother stroke and they also wear out faster.

PAINTS

A limited palette lightens your load, simplifies the mixing process and makes color harmony almost automatic. The following colors are all you need for a full palette.

CADMIUM YELLOW LIGHT. This yellow has the highest reflectivity of any color, and it is close to the center of the yellow range of hues. It also has excellent opacity.

CADMIUM RED LIGHT. This is an opaque, warm orangey red. It is an excellent color for natural-light painting. Mixed with Cadmium Yellow Light, it makes a very bright orange.

ALIZARIN CRIMSON. This is a cool, slightly bluish red. Alizarin Crimson has good tinting strength, meaning it remains colorful as it is diluted with white.

ULTRAMARINE BLUE. This dark blue supports the dark end of the value spectrum, affording a good range of values. Pure Ultramarine Blue mixed with Alizarin Crimson creates strong, rich darks (purple actually reflects less light than black and therefore is darker). Ultramarine Blue is one of the few mineral colors that is completely transparent. Ultramarine Blue mixed with Cadmium Yellow Light makes the cleanest green you can get with a limited palette.

TITANIUM WHITE. The strongest, most opaque white, Titanium White has high tinting strength and relatively fast drying time compared to other whites. Thick impasto textural applications of this color add to the illusion of light.

PORTLAND GREY LIGHT, PORTLAND GREY MEDIUM, PORTLAND GREY DEEP. These grays are an interesting alternative to mixing grays from white and black. They were formulated by Gamblin as neutral grays of values 4, 6 and 8 in the Munsell color system.

Neutral to start, they are useful straight from the tube for value plans and are easily changed by the addition of other colors. (Of course, I also use grays mixed from the puddles of unused paint on my palette. These grays usually lean toward various shades in the spectrum.)

CHROMATIC BLACK. This is a neutral black made from complementary colors rather than the usual carbon or iron oxide blacks that can make mixtures look "dirty." Chromatic Black is made from a careful blend of Quinacridone Red and Phthalo Emerald. Since both of these colors are transparent, Chromatic Black is also transparent.

PHTHALO GREEN. Cool, bluish and beautifully transparent, this modern green is completely light-fast. It has extraordinary tinting strength, meaning it retains its "flavor" even in very light mixtures. Because of Phthalo Green's potency in mixtures, don't reach for it automatically whenever you need to paint something green. Create your greens with your other palette colors, then perhaps use a touch of Phthalo to heighten the intensity of the mixture.

Phthalo Green mixed with Alizarin Crimson makes a rich, dark black.

ALKYD WHITE. Alkyd paint contains oil-modified alkyd resin. It is compatible with oil paint but dries faster. When I need to speed up the drying time for transport of paintings, I replace my Titanium White oil paint with alkyd white. Alkyd white accelerates the drying time of the whole painting since it is mixed with just about all of the other colors in a painting.

Because of alkyd's fast-drying qualities, make sure to clean your brushes promptly. Alkyd sets up in about an hour, so you may need to adopt different methods of edge control, such as drybrushing edges to soften them instead of depending on wet-into-wet methods. Practice with alkyd white at home a few times before taking it on a painting trip.

WATER-SOLUBLE OILS

If you are sensitive to oil paint solvents or want easier cleanup, you may be interested in water-soluble oils. Use them in the same manner as you would oils, except that water becomes your solvent instead of spirits.

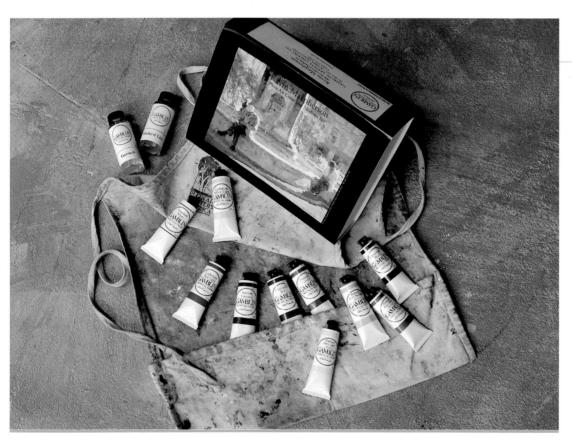

ESSENTIAL OIL COLORS AND MEDIUMS

The following colors are all you need: Titanium White, Cadmium Yellow Light, Cadmium Red Light, Alizarin Crimson, Ultramarine Blue and Phthalo Green. I also like to add Gamblin's Portland Greys (light, medium and dark) and Chromatic Black, which is a nice transparent black. A medium such as Galkyd Lite is also useful (see page 16). Shown here is the "Kevin Macpherson Plein Air Palette: Landscape Inside Out," available through Gamblin Artist's Colors. Whichever brand you use, it helps to use the same brand for all your colors so that your paints are consistent in flow.

For your painting surface, or support, you can buy canvas and stretch it yourself or you can choose from prestretched canvases, gessoed boards and canvas boards. I prefer to use canvas boards for outdoor painting because they're lighter and less vulnerable to damage. In the studio, I use stretched canvas for paintings larger than 16" × 20" (41cm × 51cm).

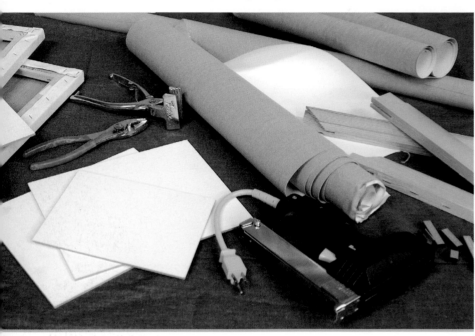

MATERIALS FOR STRETCHING CANVAS

It takes only a few tools to stretch your own canvases (shown here are regular pliers, canvas pliers, a staple gun and stretcher bars). But there's nothing wrong with buying prestretched canvases if you'd rather leave the material preparation to the experts.

ABOUT CANVAS

Canvas can be cotton, linen or polyester, primed or unprimed. Experiment with the various types and brands until you find what suits your style best. I like linen for its strength, which discourages cracking of the painted surface, and for the small irregularities in its surface which contribute to surface variety and a natural, organic look.

Canvas texture varies from ultrasmooth to coarse. On highly textured canvas, the brush can "skip," letting the color underneath show through for interesting effects. Keep in mind that a lot of texture can overpower a small canvas or a detailed subject.

GESSOED BOARDS

Gessoed board is birchwood plywood or premium untempered Masonite coated with acrylic gesso. The surface can be sanded smooth or textured with visible brushstrokes and palette-knife marks. Gessoed surfaces absorb the oily shine out of paint more than oil-primed linen does. Varnish your dry painting to even out the surface appearance.

CANVAS BOARDS

Canvas boards minimize the weight and bulk of your supplies, which helps when you're carrying materials outdoors. More quality brands have become available in recent years. RayMar Plein Air panels are archival and wonderful for travel and studio.

The thinnest, lightest type of board is multimedia board, made of paper fibers bonded with epoxy. You can paint directly on this board, but to avoid damaging its brittle surface, glue canvas to the board with PVA glue. Slide a hardboard backing behind the board while painting for extra rigidity.

Lots of information is available in books and on websites about how to prepare your own canvas boards. My book *Fill Your Oil Paintings With Light and Color* gives step-by-step instructions for mounting canvas to birchwood, Gator Board or Masonite.

CANVAS TAPED TO GATOR BOARD

As convenient as canvas panels are, there's an even lighter option: Carry five 16" × 20" (41cm × 51cm) pieces of Gator Board foamboard and multiple precut 14" × 18" (36cm × 46cm) pieces of canvas. Tape the canvas to the Gator Board with a border of masking tape. Leave a two-inch (5cm) border all the way around for easy stretching later. As your paintings dry to the touch, remove them and replace them with blank canvases. To transport the paintings, stack them between sheets of waxed paper and roll them in a cardboard tube. Fifty canvases can stack and roll easily. Stretch or mount the "keepers" later, at home.

Here's a suggestion for aligning a finished canvas on stretcher bars. With the paint side up, use a pushpin to make a small hole through the weave of the canvas at each corner. Turn the painting over to the unpainted side and draw pencil lines connecting the dots. Use these lines as your guide for aligning the painting on stretcher bars.

PALETTE

I like seeing my paints against the medium-value color of a natural wood palette. I use an enclosed, folding palette that fits on my French easel. The sides open out for space to lay brushes, tissues and spirits. At the end of a session, the palette just folds up, and the paint stays fresh.

After each use of my wood palette, I scrape the colors off with a palette knife and wipe the palette with a spirit-soaked tissue, leaving a slight film of paint to dry to a glass-like surface. Prime a new wood palette with oil, spirits and a thin paint film a few times until the new wood surface becomes less porous.

Whatever kind of palette you use, I recommend a large surface with plenty of room to mix clean colors. Some people prefer a white surface against which to judge their colors. Handheld palettes are good because they allow you to move back and forth while mixing.

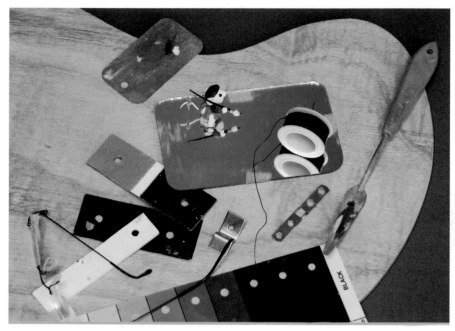

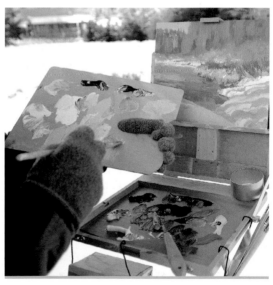

MY PALETTE
The ProChade kit that I use (see page 20) includes an extra detachable palette extension. Here I have mixed my "light family" values on the handheld palette and my "shadow family" colors on the main palette. The detachable palette allows you to step back from the work and keep active.

COLOR ISOLATORS

Color isolators are invaluable when you're trying to judge nature's overwhelming variety of color. By looking through the viewing hole, you can see and evaluate a particular color in a scene in isolation. Some isolators include gray scales to help you determine relative values. You can buy color isolators or make your own by punching a hole in a white, black or neutral-gray card.

VIEWFINDERS

Look at a scene through a viewfinder to test out different compositional arrangements. When you're confronted with a rich outdoor vista, it may be better to paint one small area of it rather than the entire scene. A viewfinder can help you see this. Any frame with a rectangular opening can serve as a viewfinder, even a slide mount.

OTHER USEFUL ITEMS
Store-bought color isolators are useful, but any found object with a hole in it can serve as a color isolator (such as the hole in a palette knife handle).

A mirror lets you see your work in reverse for a fresh perspective.

Thin black wire is a good value comparison tool. Hold the wire across an isolated spot of dark color to see its true relativity compared to black. Sometimes I use my black wire-rimmed glasses for this.

VIEWFINDERS
Make a viewfinder by cutting a window in a piece of mat board. Cut many viewfinders in proportions corresponding to the various canvas proportions you use.

SOLVENTS

Using odorless mineral spirits instead of turpentine reduces your exposure to solvent vapors. I use Gamblin Gamsol Odorless Mineral Spirits because it is highly refined and contains no harmful aromatic components.

I recommend using mineral spirits mainly to clean brushes. There is ample oil in tube paints today; it usually is not necessary to make paints more fluid with solvent. Too much spirits will cause the paint film to be weak. For thin underpainting layers, you can use a medium (see below), rather than solvent only, to thin the paint while decreasing drying time.

MEDIUMS

The main purpose of mediums in direct painting is to dilute oil colors to increase their flow. They also decrease drying time. Generally I like keeping my paint wet so I can manipulate edges for as long as possible. I occasionally use mediums for underpainting layers.

Gamblin Galkyd and Galkyd Lite are two mediums that create a strong paint film and can be thinned with odorless mineral spirits. Galkyd medium can replace natural resin painting mediums. It speeds the drying time of oils. Galkyd Lite is less viscous than Galkyd. Its viscosity is similar to that of a traditional damar/refined linseed oil/turpentine painting medium.

Like alkyd white paint (see page 13), Galkyd mediums will also cause paint to dry quickly on your brushes, so clean brushes promptly.

VARNISHES

A final coat of varnish protects a painting from smoke and dust. It also evens colors out to a uniform finish, from matte to glossy, and makes colors appear more saturated. Varnish needs to be soluble for future conservation. I like Gamvar because it never yellows and can be removed from a painting with mild solvents if necessary.

Retouch varnish is more diluted than picture varnish and can be used to even out dull areas and to freshen colors and values while you are working on a painting. It can also be used as an interim varnish until the painting is thoroughly dried, after which the final varnish can be applied. (A painting should dry for six to twelve months before final varnishing.)

OTHER HANDY ITEMS

BABY WIPES OR MOIST TOWELETTES. These easily clean wet paint from your hands, clothes or even car upholstery.

LAUNDRY PRE-WASH STAIN REMOVER. In packets or roll-on sticks, a stain remover is great to keep in your art bag to remove paint from clothes.

SOLVENTS, MEDIUMS AND VARNISHES

My larger tin solvent can has a screen divider to keep the pigment below and cleaner spirits above. I pour the soiled spirits off into an old glass jar. I use tiny cups or caps to hold medium.

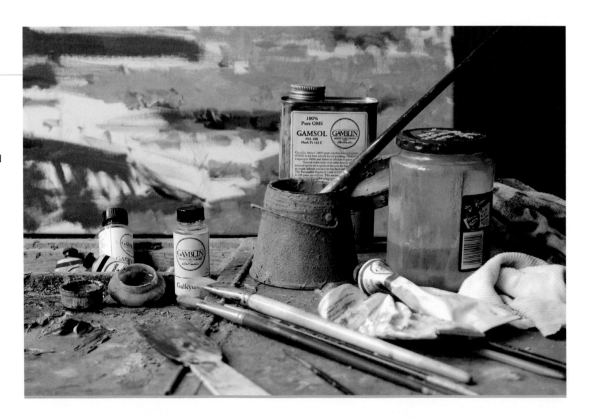

RAGS. Old lint-free t-shirts are good for wiping a canvas either to make corrections or to stain or tone the canvas.

PALETTE KNIVES. These serve several functions: mixing paint, cleaning your palette, scraping off areas of a painting that need correction and adding interesting textures to a piece.

TISSUES OR PAPER TOWELS. I find tissues more efficient than paper towels, because it is quicker to pull out a fresh tissue than to unroll a towel.

SOLVENT CUPS OR JARS. A small cup that slips over your palette is handy. A double cup can have clean solvent for thinning mixtures and "dirty" solvent for brush cleaning. In the studio, I have a larger solvent can with a screen against which to rub the brushes. The pigment particles then settle out into a lower section of the cup. Cups with locking tops prevent spillage in transport.

PAINT TUBE WRINGERS. These make it easier to extract all of the paint from your tubes.

TUBE WRINGERS
Tube wringers ensure that you get every last drop of paint from the tube.

Solvent Safety Tips

○ Have plenty of ventilation in your studio. Refresh your lungs by walking outside frequently.

○ Pour your used solvent in a large jar. Cover the jar and let it sit overnight. The pigment will settle to the bottom. Pour off the clear top layer of solvent and reuse it. Eventually you'll have a large jar of gray pigment. If none of your paints is labeled with federal health warnings, the sludge can be disposed of with regular household trash. Otherwise, contact your local recycling facility to find out where to take hazardous waste material.

RESUMING WORK ON A PARTLY DRIED PAINTING
At times you may want to continue working on a painting that has become too dry to work wet-into-wet. First, sand it lightly with fine sandpaper to keep textural passages from showing through in inappropriate places if your painting changes drastically. Put on disposable rubber gloves, then rub a thin film of Galkyd Lite medium over the canvas. You can then paint into this layer, which will act as an adhesive to the lower layer.

Almost every artist would like more space in which to work. Do not let the lack of that perfect studio hinder your efforts. Many artists spend time and money designing and building the perfect art studio primarily to avoid getting down to the actual business of painting.

THE ESSENTIALS

A functional studio needs these basics:

AN EASEL. My studio easel is a Hughes 3000. It is great for various sizes of canvas and easy to lift up, down or across, which is convenient for a large canvas.

ENOUGH SPACE. You should be able to step back from your easel and assess your work.

A PLACE TO PUT YOUR BASIC SUPPLIES. A taboret or a rolling kitchen cart with a few drawers and shelves works well and provides a good, flat work surface.

WINDOW LIGHT. North-facing windows are the ideal light source because north light is the most consistent daylight. Much like an overcast day, north light is relatively cool. South, east and west windows will be pierced with direct sunshine; as it sweeps through your studio, be aware that it can reflect off many surfaces and change the color ambience of the room. I take advantage of direct sun through windows for still life setups, but it does change rapidly.

ARTIFICIAL LIGHTING. A cloudy day may provide insufficient light—or you may be a night painter, finding inspiration and refuge from your daily duties at night. Supplement your window light with color-correct daylight fluorescent bulbs in ceiling fixtures. You might also like to have a few incandescent lights, which are warmer, to balance out the coolness of other light sources. Try to illuminate the subject, your easel and your palette with the same light.

GALLERY
Hang art in your workspace to set the mood for painting and to celebrate your accomplishments.

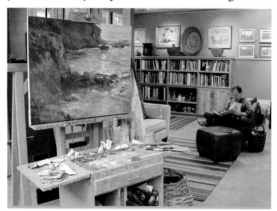

LIBRARY
Keep your art books near where you paint for quick reference and inspiration.

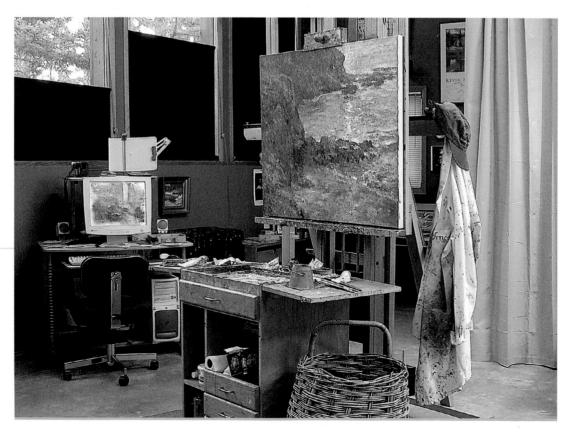

MY WORKING SPACE
I like to put my taboret in front of my easel. The added distance keeps me a full arm's length away from the canvas so I am seeing the whole painting as I work. My computer is nearby so that I can refer to digital photos on its flat screen.

ALSO NICE TO HAVE . . .

You may find other items useful in your studio, as space permits:

A LARGE MIRROR. Viewing your art in reverse lets you examine it with a fresh perspective.

CABINETS. Paints, varnishes, gesso, paper and other supplies can be stored there.

STORAGE FOR SLIDES AND TRANSPARENCIES. Keep slides of past paintings so you have a record of your work and so it can be reproduced in print if the opportunity arises.

SPACE TO HANG FRAMED PAINTINGS.

A COMPUTER. A computer is useful for notes, correspondence and record-keeping. A large flat screen is excellent for viewing digital reference photos.

A STEREO. Fill your studio with music to paint by. Music has great power to transport you back mentally to the outdoor place you are painting.

SHELVES TO HOLD PROPS FOR STILL LIFES. Search flea markets for glassware, pottery, silk flowers—anything with interesting textures, colors, shapes or patinas.

BOOKSHELVES. Art books of all kinds can provide instruction, problem-solving tips and inspiration.

A DRAFTING TABLE. Mine is a relic from my advertising days, but I still find it useful for planning paintings and for sketching.

SPACE FOR FRAMING AND FRAMING SUPPLIES. I have a large rolling carpeted workbench for framing, stapling and packing paintings to be shipped.

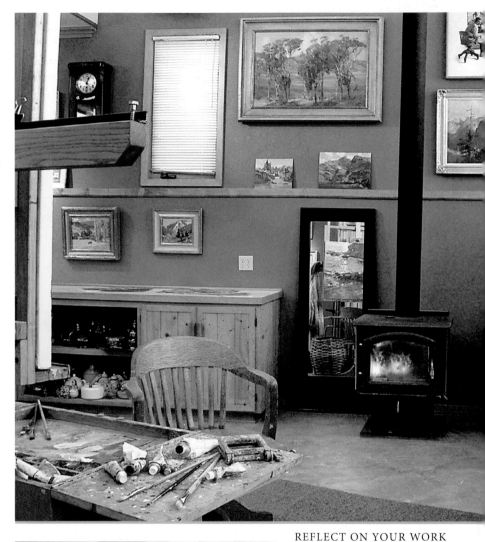

REFLECT ON YOUR WORK
A mirror placed strategically behind your easel lets you turn for a fresh look at work in progress. The reverse image reveals flaws such as unwanted diagonal lean in the drawing.

Keep Your Studio Ready for Action
Always have ample supplies on hand, such as paints and a good inventory of canvas boards and stretched canvases, both inexpensive and professional quality. On the days you are not feeling especially creative, stretch and tone canvases or order supplies. Then, when you are ready to create, you won't be interrupted by preparatory necessities.

FILING AND FRAMING
I photograph my finished paintings and file them by title. I also file my scenic reference photos. For framing, I have a carpeted, rolling workbench.

Your outdoor studio setup must be complete, yet lightweight and portable—especially if you plan to travel by air, bus, train or a small rental car.

Packing light also lets you move faster in response to changing conditions outdoors. The most dramatic light for the plein air painter often occurs in the early morning or late afternoon, when the sun and the shadows change rapidly. Being able to set up and paint quickly is a must.

Even after all those years in the field I still keep a checklist and double-check my supplies before I go out.

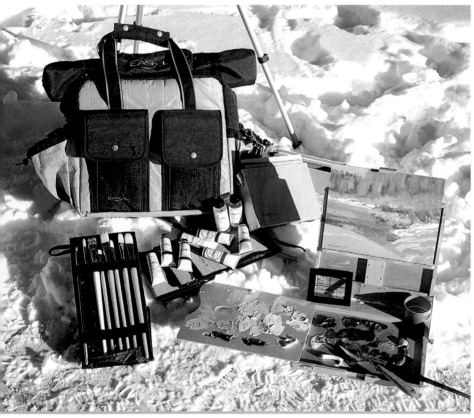

Photo by Bill Leibow

MY "PROCHADE KIT"

I designed the ProChade outdoor painting kit for Artwork Essentials (www.artworkessentials.com). It holds a pochade box, a slot box, a padded brush wallet and all the necessary supplies in a bag that complies with FAA carry-on guidelines and weighs less than 10 lbs. (4.5kg). The detachable palette extension provides extra space for supplies or color mixing. The adaptive panel support holds canvas panels of various sizes, up to 10" (25cm) in height and any width.

FRENCH EASEL OR POCHADE BOX

A French easel is a wooden sketch box that quickly converts to a sturdy easel and includes a palette. The legs adjust to various heights for uneven ground. There are also models with half-size boxes convenient for travel and backpacking. Pay the extra money and buy the best available. Your French easel can also serve you well indoors.

A pochade box is a small paint box with a built-in palette. My ProChade easel (shown at left) includes a tripod mount so that you can attach it to a tripod. A quick-release tripod mount makes setup faster and more convenient.

CANVAS PANELS

See page 14 for a variety of options, and pick whatever works for you. "Lightweight" is the key.

WET CANVAS CARRIERS

A wet canvas carrier or "slot box" is a must for transporting your wet paintings. Get a lightweight one that can transport multiple canvas sizes. For example, a 16" × 24" (41cm × 61cm) carrier can accommodate any smaller size with a 16" (41cm) side, such as 12" × 16" (30cm × 41cm), 16" × 20" (41cm × 51cm) or 16"× 16" (41cm × 41cm). RayMar and Easyl make light-weight, affordable canvas carriers.

PAINTS AND ESSENTIAL TOOLS

Bring enough supplies for the duration of your trip. Art supplies are not always easily located.

PAINTS. Wrap each tube of paint in small-celled bubble wrap or cushy foam sheets, then seal them in a zippered food-storage bag. This prevents the mess that occurs when the vibration of travel causes the corner of one tube to dig into another tube.

SMALL CAN FOR SPIRITS. It is illegal to transport flammable materials on an airplane, so pack empty solvent cups or containers for your daily solvent needs. Before you leave, find out where to buy art supplies at your destination.

PAPER PALETTES. Although a bit too absorbent, these palettes are disposable and good for travel.

SKETCH PADS. These are handy for small sketches and written notes.

VIEWFINDERS. The landscape outdoors can be overwhelming. Looking through a viewfinder helps to isolate and simplify the scene in front of you. Any small frame can serve as a viewfinder. An empty 35mm plastic slide mount works great, or you can cut a rectangular opening proportional to your canvas size into a small piece of cardboard.

DRY-ERASE MARKERS AND A SHEET OF ACETATE. Tape the acetate to your viewfinder like a windowpane. Close one eye, hold the viewfinder steadily and trace the scene as you see it with a dry-erase marker. The marker cleans off easily for re-use. In this way you can quickly diagram a scene and place the key objects in a two-dimensional plane.

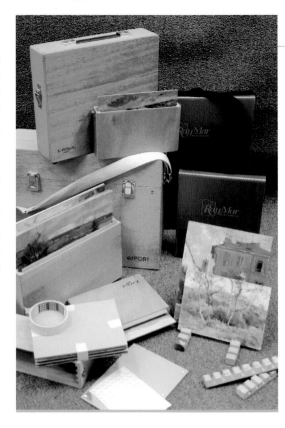

WET CANVAS CARRIERS
A canvas carrier or "slot box" is essential for carrying wet paintings back to the studio. As an alternative to a carrier, you can stack wet paintings with rubber cushion feet between them, then tape the stack together.

OTHER SUPPLIES TO BRING

- Plenty of drinking water.
- Bug spray. I sometimes spray the ground I'm standing on to protect from nasty fire ants, mosquitoes, yellow jackets, gnats and flies that wreak havoc on concentration.
- Camera.
- Compact mirror to look at your painting in reverse, letting you critique it with a fresh eye.
- Trash bags
- Pencil
- Pen knife
- A hands-free battery-powered headlamp, available at camping stores, so you can view your work surface when painting nocturnes.
- A clip-on, battery-powered book light to illuminate your canvas and palette while painting nocturnes.
- Folding stool. Sitting down may be comfortable, but just be sure to get up regularly, step back and compare your canvas to the scene.
- An umbrella that clamps onto your easel to keep the sun off your canvas, your palette and yourself.
- A cellular phone for emergencies. I also advise having a painting partner for painting in questionable areas.
- Business cards or bio sheets to give to interested potential patrons.
- Pliers for opening stubborn paint tubes.
- Duct tape.
- A tiny bubble level for leveling your easel on uneven ground.

- A compass for anticipating the direction of sunlight
- Bungee cords.
- A tarp for beach painting. Set your supplies on the tarp to keep sand off.
- Waxed paper to lay between nearly dried paintings.
- Folding nylon auto windshield sunshade. It is lightweight and folds for easy storage. Wedge or clip it to your easel to keep sun off your palette. You can also set your supplies on it in lieu of a plastic tarp to keep the supplies off of sand or wet ground.

WHAT TO PACK IT ALL IN

A backpack will make your life easier. For maximum versatility, look for one with wheels and a pull handle.

WHAT TO WEAR

Wear clothing that is neutral-colored and not white. Bright light and bright colors will reflect into your canvas, making it difficult to see and compare colors. A white shirt reflects too much glare.

To stay comfortable, wear shoes that are good for walking and standing, and dress in layers so you are prepared for changing temperatures.

Be prepared for the sun. An outdoor painting session may seem to fly by, while you may actually be standing in the sun for hours. Bring a hat and sunblock. I don't recommend wearing sunglasses. They make it harder to judge color and value, and polarized sunglasses create unnatural effects.

Always plan for the possibility of rain. Bring a raincoat or poncho that can fit over you and your bag or backpack. In light drizzle you can still work under an eave or an umbrella. Bring a large garden trash bag to cover your backpack if it rains.

VERSATILE LUGGAGE
A backpack with wheels is ideal for painting in the field. Wear it or roll it as needed. I'm carrying my wet panel carrier; everything else I need is in the backpack.

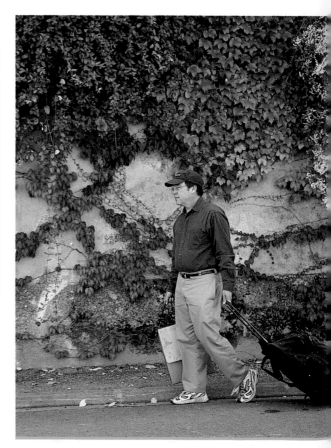

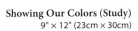

Showing Our Colors (Study)
9" × 12" (23cm × 30cm)

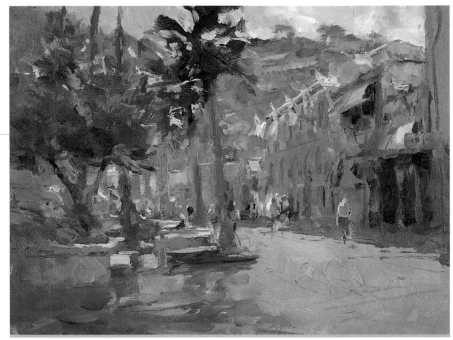

OUTDOOR STUDY, INDOOR PAINTING

The small study was done on location in one session. I liked the painting and looked forward to doing a larger one. I set up the following day with the large canvas. This canvas was larger than I usually paint on outdoors, but the previous day's exercise made the composition come together more easily, as I had already answered many of the visual questions.

I did not finish the large canvas the first day. Subsequent rainy days prevented me from finishing on location. Back in the studio, I used my original study and photo references to complete the large painting.

Showing Our Colors
20" × 24" (51cm × 61cm)

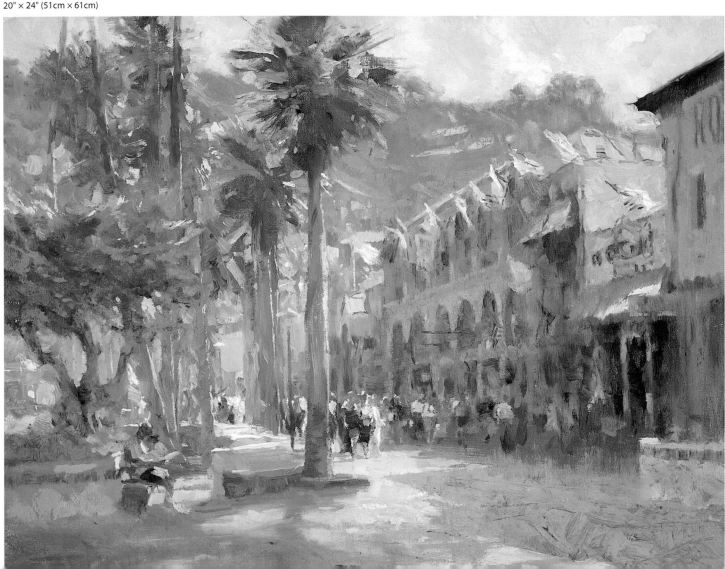

2

TECHNIQUES

In chapter 1, we talked about choosing the right paints and brushes. This chapter is about learning to use them. With practice you will become so comfortable mixing colors and handling your brushes that they will feel like extensions of your hand, your mind—indeed, your eye.

Use the exercises and suggestions in this chapter to get acquainted with your palette and to learn the power of all your colors. Also try the wet-into-wet style of painting that I describe on page 29. As these color mixing and painting techniques become second nature, you will be able to paint more creatively and impulsively, reacting to the moment.

I don't emphasize brushwork, for I believe the objective is to fill in the abstract shape with the proper color and value. Do not create fancy, slick brushwork just to impress.

Your brush is your color baton.
You are a paint majorette.

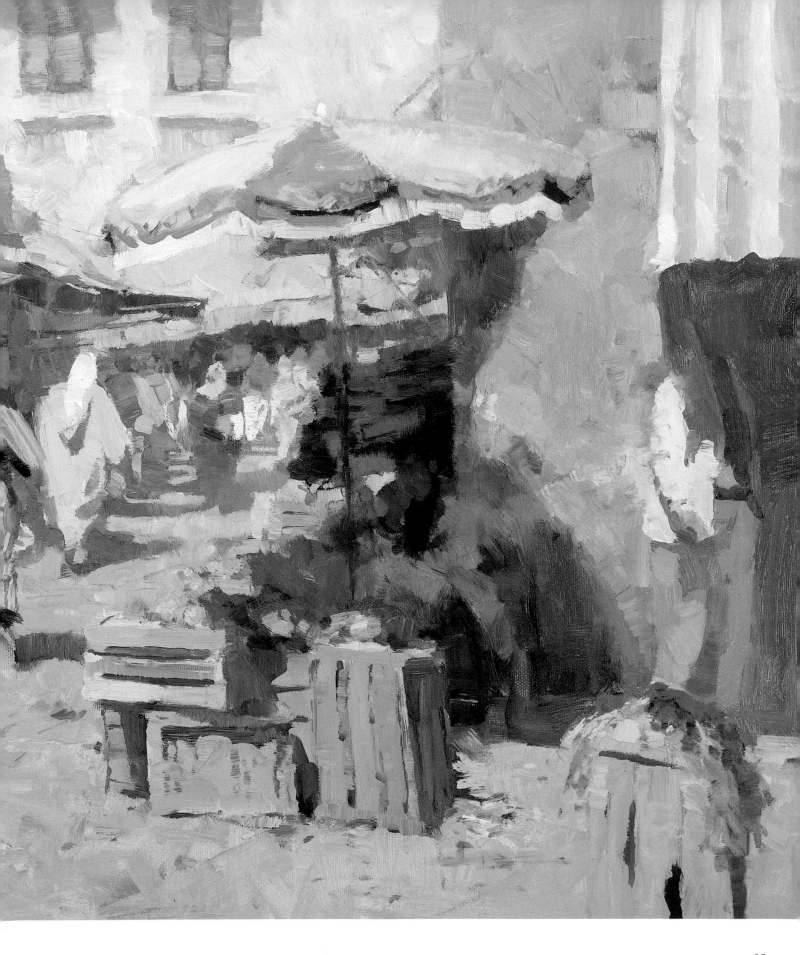

1. PREPARE

Set your colors out in the same position every time you paint. To act impulsively and to keep up with the transitory effects of nature, you must know exactly where each color is on the palette.

Mixing will be easiest if all your paints have equal viscosity. When the paint is too stiff, you can lose your rhythm. You want to be able to grab paint with the brush and mix it quickly. Usually all of the paints within a certain brand are similar in viscosity. If you need to correct the fluidity of a color, mix in a small amount of linseed oil or medium with a palette knife.

The Power of a Limited Palette

A limited palette is more liberating than limiting. With a limited palette of three colors plus white, you can create all of the color and value relationships you need for a painting, and you will truly understand the process.

If you're not sure whether a limited palette of colors is enough, try this experiment. Lay out your six basic colors (Cadmium Yellow Light, Cadmium Red Light, Alizarin Crimson, Ultramarine Blue, Phthalo Green and Titanium White) on your palette. Then lay out all your other favorite tube colors. With mixtures of just those six colors, try to match all your other tube colors. Once you learn that you can mix all those colors, you'll have the confidence to use a limited palette.

2. MIX

Pre-mix clean secondary and intermediate color piles with a palette knife. For the purest possible color, mix with a knife and clean the knife between mixtures.

For bright, clean color when brush mixing, use a clean brush and mix in an isolated area of the palette. You can also blend the colors directly on the canvas.

Mix more than enough. The puddle can and will change to another useful puddle. Don't fear you are wasting too much paint for a small passage.

3. COMPARE

Mix two color puddles next to each other and compare them on the palette before taking them to the canvas.

Even when colors look correct on the palette, check them again on the canvas and make subtle corrections if necessary. Always ask these four questions before you commit to a color: Lighter? Darker? Warmer? Cooler?

4. ADJUST

It may take some time to get a color mixture correct. Do not hesitate to adjust a mixture back and forth—

PRE-MIX SECONDARY COLORS

Before you start to paint, pre-mix your secondary and intermediate color piles. Mix your best orange, your best purple, your best green and so on. If you've been accustomed to painting with many tube colors, this can make a limited palette less intimidating.

more of this, more of that, more of this again—until it's right. Each time you adjust, ask yourself again: Lighter? Darker? Warmer? Cooler?

Add a little bit of white to a dark mixture to make the dark color more flavorful and its temperature more evident.

Adding white obviously lightens a mixture, but it also makes it a bit cooler. Be aware of that as you make adjustments. You may have to add more warmth as you lighten a mix.

5. REUSE

As you finish with puddles of color, scrape them together to create various grays. Keep these off to the side of the palette. Instead of reaching for white to make a medium-value color, reach for that puddle of gray. These grays are in harmony with your primaries, since they are mixture of all of them—and most of nature is made of grays.

How to Change a Mixture
Much of the work of adjusting a mixture is done on the palette. When you go to shift the color and value of a mixture, always save some of the existing puddle and create the new variation alongside the previous puddle so that you can compare the two.

HOW TO SAVE YOUR GRAYS
You can buy empty, open-ended paint tubes to store your unused grays. After a painting session, put the cap on an empty tube and use a palette knife to put your grays into the open end of the tube. Tap the cap end of the tube on a tabletop to pack the paint down and remove air bubbles. Finally, crimp the end of the tube.

The object you are painting should not dictate your brushwork. Leaves, for example, do not need to be painted with small dabs; grass doesn't have to be mimicked with slender up-and-down strokes. Instead, think in terms of spots of color and plane changes. Decide on the overall shape and its proper placement, then fill in the shape with the correct color and value, using any stroke you desire. This approach will add vitality and a more natural, less formulaic finish to your paintings.

Still, brushwork is important. Thick, textural brushwork will come forward; thinner, quieter brushwork will recede. It is important to understand how the brush type influences brushwork.

- A bright (square-cut) brush will give a chiseled look to the brushwork. Brights create a very obvious, repetitive stroke.
- A filbert is slightly rounded and offers more variety. I think the filbert is the most versatile brush.
- A round brush will offer an organic, calligraphic stroke. I like rounds because they have the least influence on the character of the stroke. Your pressure on the brush is what varies the stroke.
- Sables also offer a variety in your brushwork arsenal. Their soft bristles produce a smooth-finished stroke.

It takes time to get used to any brush type with which you are unaccustomed to working. If all of your brushwork looks the same, your painting will have unity, but no variety. Mix it up a bit. Start with brights to block in, then go to filberts and maybe finish with a few soft sables.

Also be aware that the direction of stroke can change the apparent value of the color. This is most noticeable when values are close together, whether light or dark. The brush creates a textural grain that captures highlights and casts tiny shadows. The resulting value changes can be detrimental in a passage with close values, such as a sky.

Brush vs. Palette Knife

Painting with a palette knife forces you to get colors and values correct without tricks of the brush. But painting solely with a knife has limitations. A palette knife may create too little variety of paint "strokes" making for a monotonous surface texture. Try both. If you've been using only a brush or only a knife, be ready for an uncomfortable learning curve. The unfamiliar tool will feel awkward at first. Keep at it.

Viewers interpret deliberate brushstrokes as a sign of the artist's decisiveness.

PAINTING WET INTO WET

To paint wet-into-wet, use more paint, less spirits and thicker paint over the wet lower layer. Working wet-into-wet takes practice, but the longer you keep your paint wet, the longer you can manipulate shapes and edges. If a passage dries, you must either re-work large areas to get back to that wet-into-wet approach, or let the dry underpainting direct a slightly different mode of application. Both ways are valid. Some techniques and styles benefit from the interesting effect of layering over dry paint.

PAINT ENERGETICALLY

Hold the brush at the end of its handle. (You paid a lot for your brush; use its whole length.) When you do this, your arm and body, not just your wrist, are brought into action, allowing fluid and energetic brush moves. This also keeps you back away from your canvas so that you can better see your work.

Your stance is important. Move back and forth, and bend your knees. Attack the canvas as if you were fencing.

Sculpt with the brush: Add paint, carve it away. Move the brush around for various effects, strong or light pressure applied in different directions.

For a delicate vertical stroke, feel the brush's weight and find its balance point. Let gravity take the brush down; let it fall as it touches the canvas.

WHEN TO CLEAN THE BRUSH

Clean your brush or switch brushes often to keep your colors clean. However, if colors are within the same color family or value family it is not necessary to clean after each stroke. Progressively changing a color puddle may not require brush cleaning.

EXPERIMENT

Depending on the pressure you use, a hog bristle brush can paint delicate or bold marks, and it works with either thick or thin paint. Experiment with a no. 8 bristle filbert. Make bold strokes and twisting strokes. Paint small shapes with the corner or edge. Push it hard into the canvas, and tickle it softly. Try painting two shapes as close together as possible, negatively creating a narrow line between them.

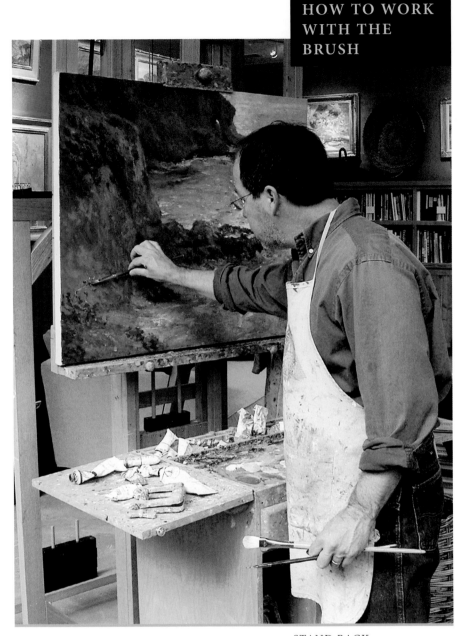

STAND BACK
Stand an arm's length away from the easel so that you can really see your work.

Loose, "Painterly" Paint

Many artists think a "loose" style of painting can be achieved haphazardly. But looseness is really a matter of direct, abbreviated brushwork that suggests rather than renders the subject. To paint loose, try to represent your subject with the fewest strokes possible. Always describe another shape with each new brushstroke.

Your brush is versatile. Use it to its fullest.

THICK AND THIN PAINT

Oil paint can be thick (right out of the tube), or it can be thinned with medium (see page 16).

Thinned paint retains fewer brush marks and dries faster, making it useful for doing underpainting layers.

Thickly applied paint, referred to as *impasto,* creates exciting, bold texture. Impasto can be done wet-into-wet, or one can build up textures layer by layer, as Monet did in his Rouen Cathedral series.

So why apply paint as if you were frosting a cake? Enjoy the tactile, sculptural qualities of your colors. Lay paint on with a knife; push it around with a brush; scrape it. Load your brush for multiple strokes; as you paint, turn the brush over and press to squeeze out more paint. Examine the work of artists who used impasto techniques: van Gogh, Edgar Payne, Nicolai Fechin. Remember, you are a painter—use some paint!

COMBINING THICK AND THIN

A painting is a combination of opposites, with unity and variety: thick and thin; opaque and transparent; bold and delicate. Artists must use as many devices as they can to hold the viewer's attention. Impasto strokes alongside thin passages enhance the painting surface and create the illusion of volume and depth.

USING A WATERCOLOR-LIKE PROCESS WITH OILS

Watercolorists are accustomed to working from light to dark. With oils it is easier to work dark to light. Because of oil paints' opacity, it is easier to lighten a passage painted in oils than to darken it.

Still, if you have experience with transparent watercolor, you can use it in oil painting. Thin the oil paint with spirits or medium to create a wash, then block in the whole scene transparently (without using white) until you are satisfied. Then add opaque paint. This combination of thin, transparent paint and thick, opaque paint will add textural variety and interest. Keep all your darks thinner and more trans-

IMPASTO

Scoop up your paint and pile it on like icing with a brush or knife. Make decisive strokes with textural interest. A thick, juicy stroke can be carved into alternative shapes easier than a very thin passage. Combinations of thick and thin paint add variety to the canvas surface.

WHY PAINT THICK?

Beginning artists usually don't paint thickly enough. They may hesitate to create bold textures or fear that they are "wasting expensive paint." Banish those fears. There are many reasons to paint thick:

- Bold, juicy, brushstrokes suggest the artist's decisiveness. Thick paint looks daring and confident.
- Impasto texture attracts attention and can be used to direct the viewer to a painting's focal point.
- It is actually easier to rearrange thick paint on the canvas than to change a thinly painted passage.

If a thickly painted area doesn't work, you can scrape it off with a palette knife. (Save the scraped paint to reuse.) Or, you can paint a new mixture over the mistake. This layering and corrective process encourages non-formulaic solutions and delights the eye in unexpected ways.

parent than the lights. Add more paint and opacity as the values lighten.

USING THICK AND THIN PAINT TO CREATE BROKEN COLOR

"Broken color" means adjacent bits of color that mix optically to produce new colors—for example, spots of yellows and spots of blues which, viewed together from a distance, appear green. Viewed up close, broken color may appear incorrect, but when you step back, it can create vibration and vitality.

There are several ways to achieve broken color:

- Apply small touches of paint, either side by side or overlapping.
- Apply thick color with a palette knife, then through this drag a brush loaded with another color, leaving a brush mark with multiple striations of color.
- Paint an area of thin, transparent paint. Let it dry, then apply thick, opaque paint patchily or streakily over the area, such that the underlying color peeks through in spots. Experiment with various ways of applying broken color, and you will create your own unique way.

BROKEN COLOR

Small touches of paint applied with a knife or brush may not look like much up close, but when the viewer sees the painting from a distance, these impressionistic touches will blend together and give the color area a depth and vibrancy that enhances its realism.

BROKEN COLOR THROUGH LAYERING

A dried, textured underpainting takes the next layer of paint in a skipping manner, so that bits of the undertone show through. The eye mixes the two layers of color. This also adds an interesting surface texture.

Texture Affects Value

Thick paint results in strokes with many ridges, each capable of capturing a highlight. These highlights will make the color appear lighter in value. Therefore, it is best to keep dark passages flatter and less textural. Scraping back a dark area will smooth it out and make it appear darker.

3

THE THEORY OF RELATIVITY

I could give you a formula for painting, but I would rather give you the secret to painting anything in any situation. A formulaic method for painting objects creates trite solutions and is very limiting. A method for seeing relationships is much more useful.

Seeing as an artist begins with understanding that art is not a matter of matching exactly what you see. The colors, values and edges available to us as painters are but a small subset of those found in nature. Painting, therefore, is a task not of matching the colors, values and edges found in nature, but of capturing their *relationships*. I call this the "theory of relativity" for artists.

A painting of a tree is not a tree, but a two-dimensional representation of a tree. Even representational artists must think in terms of abstraction.

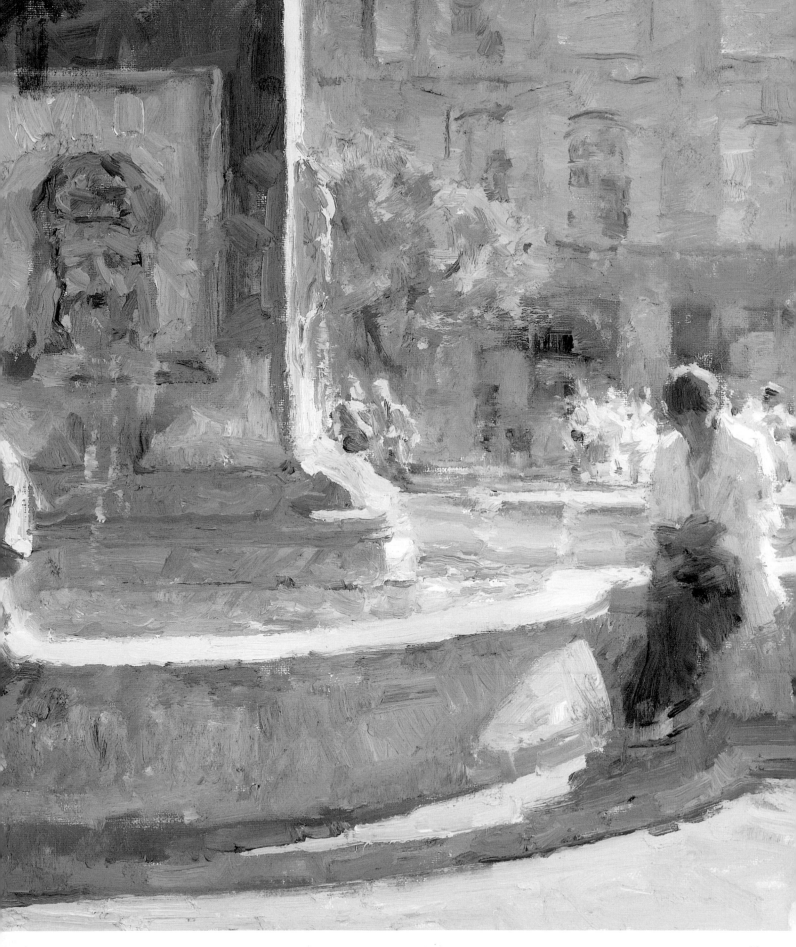

A LITTLE LIGHT SCIENCE

Representational painting is reality-based, but we must see abstractly. The first step is understanding how light affects objects.

THE CHALLENGE: LOCAL COLORS ALTERED BY LIGHT

Blue light radically alters the local colors in this still life setup. Yet our knowledge of these commonplace objects can trick our brains into seeing the lemon as yellow, the flowers and the lace as white, and so on.

This example may seem extreme, but sunlight can have very strong color casts at different times of day (as demonstrated on page 36).

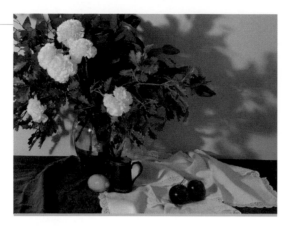

LIGHT REVEALS FORM

When light shines on an object predominantly from one direction, the light divides the shape into two distinct parts: light and shadow. Shadows reveal the object's form, the direction of the light and the quality of the atmosphere.

LIGHT AFFECTS COLOR

The color of the light shining on an object mixes with the local color of the object. A yellow lemon, for example, changes to orange when bathed in red light.

LIGHT AFFECTS VALUE CONTRAST

Light has intensity: It is soft, bright or somewhere in between. The strength of the light source and the density of the atmosphere will affect the amount of value contrast between the sunlit part of a shape and the shadow part.

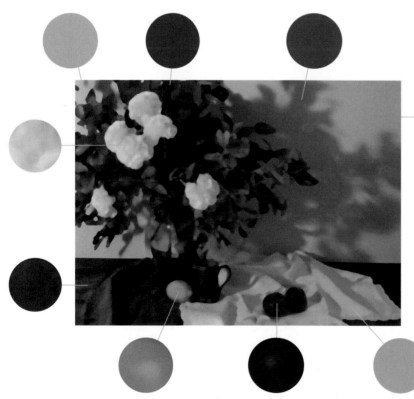

THE SOLUTION: SOFTEN YOUR FOCUS, THEN ISOLATE

Here is the same still life shown in soft focus, as if you were focusing your eyes on a point beyond your subject. (Squinting is good for seeing the important contrasts: light family and shadow family, soft edges and hard ones. But to see color, open your eyes and soften your focus.)

Isolating spots of color, as shown here, helps you see the colors without being confused by prior knowledge of these objects. The lemon is not yellow, for example, but olive green; the white lace and flowers are in fact blue. Simple tools for isolating colors are shown on page 15.

Squint to see contrast and reduce detail. Soften your focus to see color.

BLACK IN SUNLIGHT IS LIGHTER THAN WHITE IN SHADOW

I like to use this black and white cow to demonstrate how extremes in value separation create the illusion of light and shade. I prefer to use the terms "light family" and "shadow family" rather than "lights" and "darks" because both light and dark values live both in the light and shadow families. Notice that black, when sunlit, lives value-wise in the light family. Also note that the white in shade (as on the cow's tail) resides in the shadow family. The tail is darker than any of the sunlit colors on the ground. Those sunlit ground colors are in the light family. The ground colors darkened by the cast shadow from the cow live in the shadow family.

If you understand this concept, you will be able to keep your families separate and infuse your painting with light.

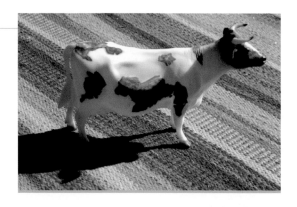

LIGHT AFFECTS VALUE CONTRAST

The photo at left clearly illustrates the principle at work in the painting below: Any color—red, yellow or blue—and any value—from black to white—can live in either the shadow family or the light family.

The Meeting Place
20" × 30" (51cm × 76cm)

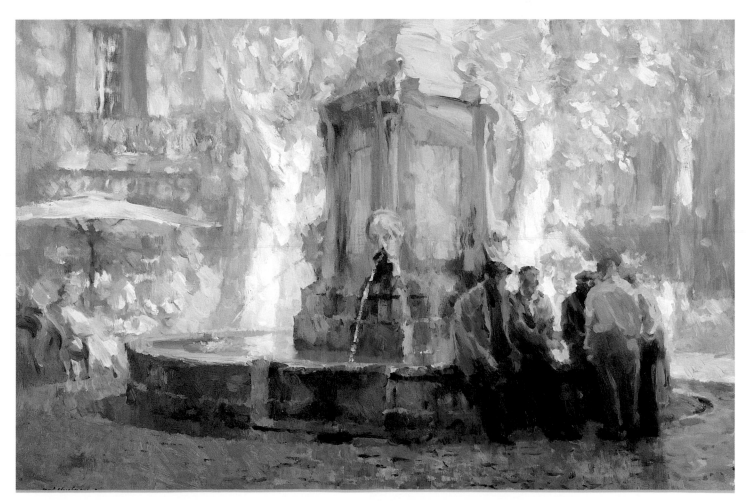

There are two ways of seeing: subjective and objective. The artist must be able to distinguish them and use both at appropriate times.

SUBJECTIVE SEEING

We see what we know. Typically, we see as much with our minds as with our eyes, classifying what we see according to memories and editing, embellishing or exaggerating what we see in order to portray our personal response to the subject. This is subjective seeing. It involves emotions, preconceptions and prejudices.

OBJECTIVE SEEING

Objective seeing, on the other hand, is the technical craft of seeing lines, values, color, shapes and edges. Basically, it is a study in visual relationships. Depicting reality on paper or canvas is an act of comparative thinking, a rational and logical process. We must not let our mind tell us what an object looks like or what color it should be. Rather, we must look, explore and discover the truth of the subject. It sounds easy, but the mind is amazingly persuasive.

HOW EACH KIND OF SEEING HELPS YOU PAINT

The first thing to understand is that when you paint an object, it is not the object that you are painting. You are painting the object influenced by the light and air between it and you. The object's local color is only a starting point. Mixing in the influences of light and atmosphere may create a very different visual statement.

Your biggest obstacle in seeing this way is preconceived ideas about objects. A tree has green leaves and brown bark, right? But if you paint it according to those formulaic beliefs, you'll miss its infinite possibilities for color, and your development as an artist will be hindered. It's important, therefore, to be able to see it objectively.

However, subjective seeing must also be added to the mix. It helps us engage our emotional response to a scene, making painting more than just a documentary process. Just as a poet selects and edits language down to its essentials, the visual artist must go beyond what one normally sees and depict a scene with artfully chosen shapes, colors and values.

THREE PAINTINGS, THREE DIFFERENT COLOR EXPERIENCES
I did three studies of the same tree at different times of day. Notice how greatly the color of the light and the quality of the atmosphere affect perceived color. Learning to see objectively is vital.

Morning Air
9" × 12" (23cm × 30cm)

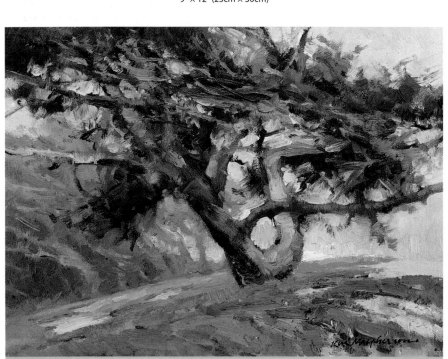

Afternoon Light
9" × 12" (23cm × 30cm)

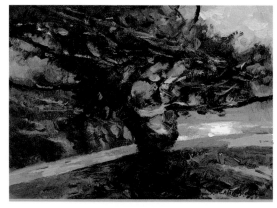

Evening
9" × 12" (23cm × 30cm)

Light reveals objects to our eyes as two-dimensional shapes. An accurate silhouette reveals the unique characteristics of an object. Have you seen the silhouette portraits that artists cut from a piece of black paper? It's just one shape, yet the likeness is immediately recognizable.

This lesson is just as applicable to the painter as to the silhouette artist. The contour of the shape is what communicates the qualities of an object—not how the shape is filled in. It is not necessary, therefore, to indicate grass with short, thin strokes or to paint string or spaghetti with long, curly strokes. Paint the flat shape with the right value and color, concentrating on getting the size, placement and proportions of the shape right.

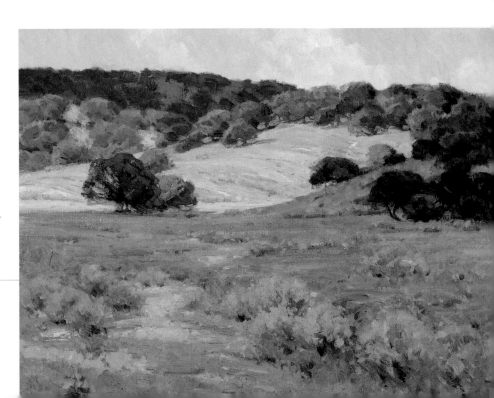

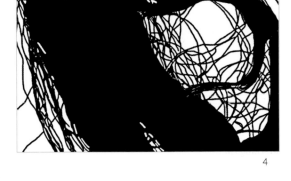

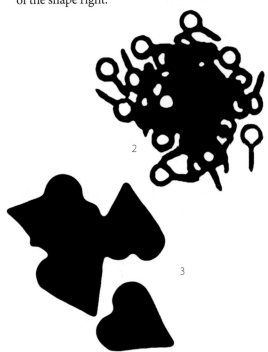

FROM A SILHOUETTE, INSTANT RECOGNITION

Shape 1 could be an extension cord or perhaps spaghetti. Shape 2 is obviously eyelet screws. In image 3, the isolated heart shape tells us that the other shape is a gathering of heart-shaped objects. The delicately linear edges of shape 4 suggest hair. In all four images, it is the perimeter contour that clues us in to what material the shape is. Isolating the center of each mass would tell us nothing.

To apply this to painting, imagine a tree as one flat mass. The interior of the mass does not explain as much as the few leaf shapes along the perimeter of the mass. Similarly, a field of flowers is not a group of tiny petal shapes but a conglomerate of color with a few isolated flower shapes around the edges to serve as explanatory symbols for the mind.

INDICATIVE EDGES

When painting a scene like this one, it is important to think "shapes," not "flowers." None of the flowers in this painting is rendered in detail. So why do we believe that these are flowers? The edges of the shape suggest what material the mass is made from. The few small bits of color away from the major mass tell us what size all those flowers are.

Colorful Hillside
24" × 30" (61cm × 76cm)

PLACEMENT AND PROPORTION

Drawing is really the placement of shapes. The first shape you place must be correct, and all subsequent shapes must relate correctly to the first one. Correct placement and proportion are the foundation of representational art. Do not let your good intentions be overshadowed by poor drawing skills. Improve your drawing by consciously practicing to get it right.

Some suggestions for this process:

◦ As you draw, ask yourself: What is the character of the shape? What overall direction best and simply represents the shape—horizontal, diagonal, or vertical? Exaggerate the qualities that best represent the object and your feelings toward it.

◦ Always define and refine an adjacent shape as you create another. This is drawing negatively.

◦ You can be generous with a shape, then carve back into it. For a difficult linear shape, stroke the color wider than it needs to be, then narrow it by painting two shapes close together over the first color.

Remember, this initial drawing is not the final answer. Generalize the shapes. Make the biggest, simplest statement first, and then refine and work the subtleties later.

ESTABLISHING SHAPES

First get the shapes down graphically, in big, general terms. Start with the general color for the shape. It's not the lightest. It's not the darkest. Maybe it's not the richest. Choose one color to best represent the shape.

As you design your shape, it's tempting to want to make it symmetrical, but symmetry won't be interesting. To build the shape, work on one side until you establish something you like, then try not to repeat that on the other side. Create variety, perhaps by juxtaposing a simple curved shape and a more irregular shape.

SHAPES MAKE LINES

As each shape collides or joins with the adjacent shape, a line is formed. It may not actually be an outline, but it is still an implied contour, either subtle or obvious. These merging passages are important to consider as part of the picture's visual significance.

THE ROLE OF LINE

Lines are a drawing convention. Line is not necessarily a thin outline as a pencil would make, but usually the place where two contrasting shapes meet. There

FROM DRAWING TO FINISHED CANVAS

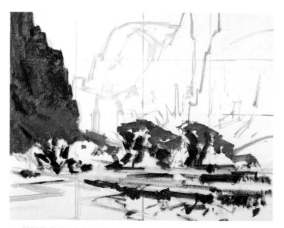

1: THE DRAWING

2

Loose painting is not an excuse for poor draftsmanship.

can also be imaginary lines connected by the eye. Lines serve several purposes in a painting:

- Lines divide the picture space, creating a design. The borders between values are implied lines.
- Lines creates a path for the eye to travel. They can be used to direct attention to the focal point (a convergence of two lines demands attention at the point where the lines cross). Lines should not lead us out of the picture.
- Repetitive lines help unify a painting as well as attract and direct the eye.
- Lines suggest mood: Diagonal lines suggest movement. Horizontal lines are restful. The quality of the lines you create—whether straight, ragged, fluid, sharp, curved, gentle, rhythmic or staccato—helps convey ideas. A fluid line might create a feeling of peacefulness; a ragged one might suggest a violent or explosive attitude.

WAYS TO MANIPULATE LINES

SOFTEN. Reduce attention to a line (actual or implied) by softening the edge of the boundary, either physically or by reducing color contrast or value contrast.

ACCENTUATE. Emphasize a line by increasing the contrast between the two shapes that create the line.

LOSE. A "lost-and-found" line is one that varies between hard and soft, distinct and diffuse. This can be accomplished through manipulation of value, color or edges. Lost-and-found lines engage the viewer to be an active participant in completing the lines mentally. The absence of line is as important as the lines selected.

CONTRAST. To show a curved line, it is best to contrast it against a straight line. The edge of the canvas is straight, so we start with four straight lines. All other lines are compared to those.

WHAT'S YOUR LINE?

Although line is implied and invisible in painting, always ask yourself these questions:

- How do the lines in the painting direct the viewer's attention? Do they keep the viewer's eye within the painting rather than lead it out? Do the lines direct attention to the focal point?
- Is there a dominance of horizontal, vertical or diagonal lines, and does the dominance communicate the mood you wanted to convey?

3

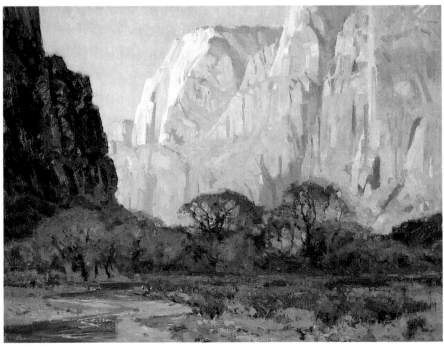

4: THE FINISH

Wake Up in Zion
22" × 28" (56cm × 71cm)

Don't ever wish you could draw a straight line. Draw an inspired line.

Turn a Photo Into a Mosaic

In a sense, a painting subject is just an excuse to create interesting abstract patterns. No matter how real a painting seems, it is still an image lying on a two-dimensional surface. This exercise will help you realize that if you just paint flat shapes of the proper color and value, place them properly and pay attention to the lines created or implied where the shapes meet, the feeling of three-dimensional space magically appears.

1 Find a Photo
Find a photo for this exercise in a magazine or newspaper (left).

You can also print photos from your computer. If you do this, try using your image editing software to create a posterized version of the photo (above). This simulates what it's like to squint at a scene and focus on the big, simple, important shapes rather than the details.

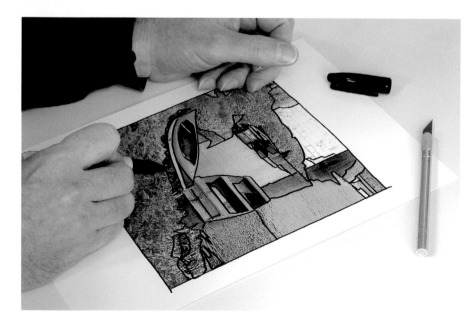

2 Outline Simplified Shapes
Use a fine-point marker to outline simplified "puzzle pieces" of color and value. Combine the less significant shapes into fewer, larger shapes. (Pretend that you have to pay me $100 for each puzzle piece you create. If you did, I am sure you would be very selective; you would eliminate the insignificant pieces and let each color you chose represent the largest area possible.)

Next, stylize (design) each shape by simplifying the irregularities into a sweeping curve or a straight line. This expresses the beauty and character of a shape better than would a tiresome, over-rendered contour. These outlines reveal a two-dimensional mosaic that creates the illusion of spatial reality.

3 Cut Out the Shapes

Use an art knife or scissors to cut out the shapes you arrived at in step 2. When a shape is isolated, you'll see that it is just a shape of a particular color. Alone, it means nothing.

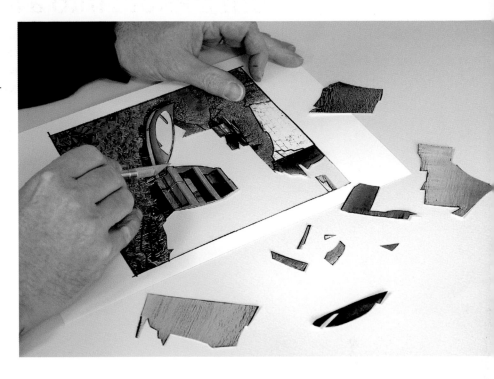

4 Mix and Match

For each shape you cut out in step 3, mix a color that matches or approximates the color and value. Then paint a matching shape on canvas. If you can do that for all the shapes and place them in proper relation to each other, then you can paint. Voilà!

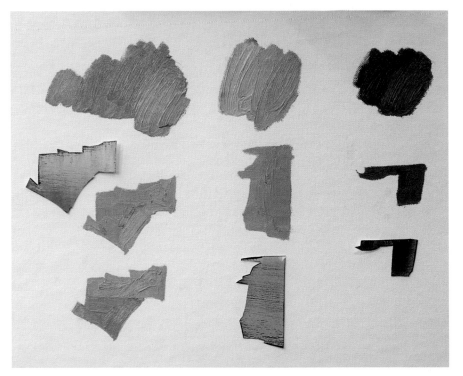

Paint the right shapes with the right color in the right place.

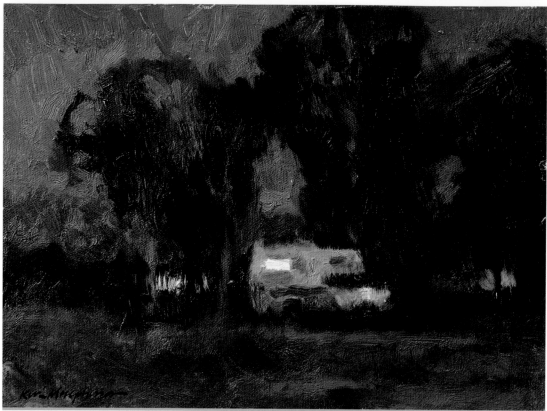

Camping
9" × 12" (23cm × 30cm)

VALUE STUDY AND FINISHED PAINTING
Painting night is challenging. I used the window light in the camper as my reference for the lightest light. The distant camp lights are darker and more orange. The remaining values and temperatures are very close, making the edges meld into each other.

Hue is the name given to a color. *Value* is how dark or light that color is. They are inherently related, and it is vital to be conscious of both. So *val-hue* is the term I have coined to describe these combined qualities simultaneously. Together, value and hue—val-hue—create mood, define form, create the illusion of space and indicate the source of the light.

Values in a painting create a two-dimensional pictorial design regardless of subject matter. A strong painting is often an arrangement of a few simple shapes of different values. This arrangement of values, if done right, can attract viewers to a painting from across a gallery.

If the values in a painting are correct, the color will most likely work, but color cannot save a painting with incorrect values. Painting is a study in relationships. Comparing each value to the others—considering not just hue, but val-hue—is a must.

REMEMBER TO SIMPLIFY
Nature is heavenly bright and mysteriously dark. Her colors can be divided into an infinite number of subtly different values. By contrast, the pigments in the artist's paintbox provide at most eight incremental values, plus black and white. So the artist must simplify nature's light, moods and infinite subtleties into these ten (at most) values. A great painting can be achieved solely within the black and white spectrum, although this is rarely done outside of illustration.

Challenge: The Black and White Picture
Paint a subject using only black, white and shades of gray. Challenge yourself as follows:

- How few shapes can you use to portray your subject?
- How simply can you arrange the shapes?
- What overall value dominates the scene? What range of values depicts the atmosphere the best and sets the mood you want to convey—high key or low key? Within the chosen range, how few values can you use to describe the subject?

DESIGN WITH VALUES
Although this composition is colorful, I designed the major shapes with value. Simple values corral the colors into an organized arrangement.

Footsteps of Lautrec
12" × 16" (28cm × 36cm)

Ten values, millions of colors.

Assign Colors to Match the Planned Values

In your value plan, you assign values to shapes. As you paint, you are assigning colors to those shapes. For each shape, choose a color whose value matches the value you assigned to that shape in your value study. If you establish an effective value plan but then choose val-hues that don't correspond to it, the painting probably will not succeed.

As you are mixing your color, always test a small dab on the painting. You can hold a piece of red acetate over an area of a painting to block out the color and see whether a certain color resides in the right value family. Ask yourself: Does it need to be lighter or darker to be the correct val-hue? Adjust the mixture if necessary, then commit.

Color Has Inherent Value

To understand how values underlie even the most colorful paintings, turn down the color on your television set until you have a black and white image. The picture Is void of color, yet it is intact and totally understandable.

When you paint, think not only about the colors you are using, but also about their values. If the color were stripped away as in your television set experiment, would the remaining value patterns make sense? Color inherently has value.

1 Start With a Value Sketch

Before starting any painting, do a value sketch with black, white and gray on paper, canvas scraps or boards. You can do your value sketch with pencil, markers, watercolor or tube grays and black. If your value plan is successful, it will keep you from going astray as you assign colors.

2 Choose Colors That Fit the Assigned Values

Once you have determined your value scheme, concentrate on finding color notes that fall within these values. The color you choose for each shape must reside within the value you assigned to that shape.

3 Test Yourself

As a test, take a digital photo of your finished painting, then use your image-editing software to change the photo to grayscale. Does it look like your value plan?

HOW A LIMITED PALETTE CREATES COLOR HARMONY

Color harmony is almost automatic when you use a limited palette. Red, yellow and blue, being the primary colors, are as different as colors can be. There is no harmony between them. Once they are mixed, it becomes possible to find harmonies among the mixtures. Every color in a painting probably contains at least a little of all three primary colors.

I ask my workshop students to try a limited palette of three primaries plus white. After some initial fear and disbelief, they find that a limited palette can satisfy their colorful appetites, and they are amazed at the endless color choices at hand. (I can't have my students *too* comfortable, so lately I've been having them use a set palette of only Yellow Ochre, Cadmium Red Light and black. This limits the intensity of their mixtures, but not the potential number of relationships.)

OTHER STRATEGIES FOR CREATING COLOR HARMONY

FIND COLOR RELATIONSHIPS AND HARMONY WITHIN EACH SCENE. At times I key a painting to a particular set of color relationships I have in mind, but most often I capture what I see. To create color harmony, look for the similarities between colors, not the differences. Imagine, for example, a red house in a green field. Red and green, being complementary colors, are different. But the barn can have green mixed into the red, or the grass can be grayed down with some red. By making one of the colors less pure, we can allow the two to coexist more harmoniously.

UNITE THE SHADOWS WITH COLOR. Mix one color (or multiple shades of one color, such as a range of purples) into all of the shadows in a painting.

AT THE START OF A PAINTING, CHOOSE ONE PRIMARY AND MIX IT WITH THE OTHER TWO PRIMARIES. Draw from these puddles for all subsequent mixtures, so that every mixture in the painting has something in common. The two other primaries will obviously be less pure. For example, if we added a bit of yellow to the red and blue we would have yellow, red-orange and blue-green as our palette, resulting in a warm tone to the final painting.

OBSERVE THE UNIQUE LIGHTING AND ATMOSPHERE OF EACH DAY TO INTRODUCE NATURE'S HARMONY—NOT FORMULAIC HARMONIES—TO A PAINTING. Quickly glance at your subject, then shut your eyes. What harmony, mood and overall color quality does the scene exude? What one color is predominant? Trust yourself. Did it feel orange, green or blue? Key all your colors to that color family by adding a bit of it to all the mixtures in the painting.

Remember that the right color is not necessarily the exact color. It's a matter of establishing the same color relationships with a simpler palette than what you see in nature. Whatever palette you use for a painting, plan your color relationships to work within the range available. For example, you might ask yourself: What will be the brightest red in this painting? If your palette has no red, only purple, then purple is as red as you can get. Relate all other colors to this extreme.

USE GRAYS. Grays or neutrals are an extreme example of color harmony. Grays are mixtures of two, three or more colors. Combining all the primaries in this way helps unify a painting. Sensitive shifts in temperature (color) of your grays add variety within these unifying delicate neutrals. Grays look gray in comparison to the pure tube colors in your palette. But upon closer examination you'll see that in relation to each other, grays come in all the shades of the rainbow: green, red, yellow, blue, brown and purple.

Weaning Yourself From a Large Palette

If you are intimidated by the thought of having only three colors, expand your limited palette. Mix yellow and red to make the best orange; yellow and blue to make the best green; and red and blue to make the best purple. Then keep these on hand throughout your painting session as if they were tube colors. Because they are mixed from the original primaries, your green, orange and purple mixtures are more harmonious secondaries than tube colors would be.

The terms "color" and "temperature" are interchangeable. As you examine any color, ask what its temperature is: Does it lean toward cool or warm? As you compare colors, judge their warmth or coolness in relation to each other. For example, Cadmium Red is warmer than Alizarin Crimson, so we might call Alizarin Crimson cool. But compared to green or blue, Alizarin Crimson is warm. In isolation, a color means nothing.

HOW TO CONTROL COLOR

PAINT THE PUREST COLOR NOTE FIRST. To manage the range of color notes in a painting, paint your purest color note first, and key the rest of the painting to that. Take, for example, a scene containing a hot red setting sun. Since this setting sun is the most intense light source in the painting and is also rich in color, it's best to paint it with the reddest red available to you on your palette. Then judge all other color relationships in the painting against that purest note.

Continuing with this example, if you were to paint the background and surroundings in this landscape before painting the sun, chances are you would not have planned the value range properly. You would mix a red for the sun, but in order to make it lighter and brighter than any other red in the painting, you would have to add white to the mixture—at the expense of the richness of the red color.

LOOK FOR THE "FLAVOR" OF SUBTLE OR DEEP COLORS. Look carefully at pale pastels, subtle grays and deep rich darks, and ask yourself: Is it yellow, red, blue or green? These delicate colors and deep darks do have color, but if you don't look carefully you may miss the chance to add beautiful temperature variety to your painting.

REFINE SHAPES WITH TEMPERATURE CHANGES, NOT VALUE CHANGES. Students frequently go astray after the initial block-in and lose the initial value plan. To indicate light/shadow or form changes within a shape, refine it with smaller shapes that contrast in temperature rather than value. All the colors within a value shape must live within that value.

HOW COLOR CONTRAST WORKS

COLOR CONTRAST DIRECTS THE EYE. Strong color contrast—such as red next to green or an intense color surrounded by neutrals—will attract attention. To reduce attention to an area of a painting, reduce the color contrast.

COLOR CONTRAST ENHANCES DIVISIONS OF LIGHT AND SHADOW. You can indicate light and shadow with value contrast alone, but using value contrast plus color contrast is usually more effective and more interesting. For example, if the sunlit part of a tree looks green, look for any other color except green on its shadow side, and paint what you see. Once you are aware of the color possibilities you will find them. This contrast will heighten the illusion of light and shadow, and enliven the painting.

LOOK FOR CONTRASTING COLORS IN THE SHADOWS

I used colored gels to light this still life setup with red, then yellow light. Notice that in each case, the shadow areas contain the complement of the light's color.

Use this principle to enliven the shadows when you are painting a naturally-lit scene. If the sunlight is reddish (as it can be in the evening), search for greens in the shadows. If the light is yellow, try to find the purples in the shadows.

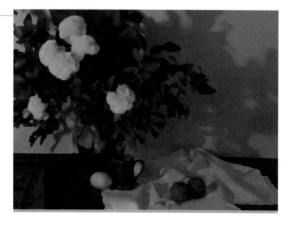
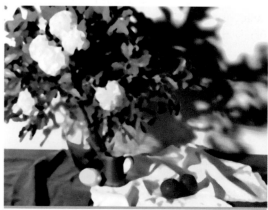

If every area is screaming for attention, no area is noticed.

Sensitize Yourself to Color

No color in a painting lives in isolation. Within any color family (such as greens), close observation reveals range of variations: darker, lighter, purer, duller, yellower, redder, bluer and so on. This exercise will sharpen your skills of color observation, enabling you to find the subtle variations of temperature and value within a scene that seems dominated by one color family (such as a landscape that looks overwhelmingly green).

1 Observe Colors and Take Notes

Walk around inside your home and look for as many different greens as you can find. Take notes, identifying colors or objects with specific references such as turquoise, lime, sage, ocean, evergreen, army green or "the green my childhood bedroom was painted." These color references will make it easier to home in on the correct val-hue.

2 Mix the Greens

With a palette of Cadmium Yellow Light, Cadmium Red Light, Alizarin Crimson, Ultramarine Blue, Phthalo Green and white, mix each of the greens you found in step 1. Start with yellow; add blue. Ask yourself whether the color needs to be lighter, darker, warmer or cooler. Add a bit of red, perhaps a little white or a touch more blue, until your mixture approximates the green you see.

Compared to reds and blues, all of the colors on your palette will look green, but when you examine them closely you will find that these puddles are a rainbow of answers.

Say the Color

While painting, speak to yourself, either silently or out loud. Declare the color note when you find it in your scene, and say it again as you seek the correct mixture. This is just one more way to help you get the right color puddle.

Edges are where one shape meets another. Edges in a painting need to be compared just as values and colors do. Within a painting there is a hardest edge and a softest edge. All other edges relate to those. With practice, you can develop your sensitivity to edges and see these same relationships in nature.

WHAT EDGES DO IN A PAINTING

- Edges suggest the quality of the atmosphere, as when distant or fog-obscured objects look softer, or close-up, brightly lit objects look sharper.
- Varying your edges gives the viewer areas of intrigue and mystery.
- Edges direct the viewer to the focal point. When you look at a scene with your eyes, only the area you're looking at directly is in focus; everything in your peripheral vision is out of focus. Use edges in your paintings the same way.
- Edges suggest the physical properties of objects. The side of a house will be harder-edged than the rounded form of a bush.

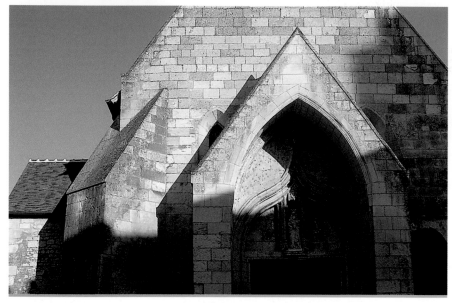

TRAIN YOURSELF TO OBSERVE EDGES
The value of the shadow shape on the façade of this ancient cathedral doesn't change much. The edges where shadow shapes greet light shapes, however, range from soft to crisp.

EDGES AT WORK
The fine drizzle on this day softened all the shapes and edges. However, sharp edges are also needed in the painting to direct the eye throughout the canvas. The sharper edges and stronger contrasts alert the viewer to points of interest. They stimulate the eye to move and refocus, sliding over soft and subtle contrasts and pausing at the accents of color, value and edge contrasts.

Rainy Day, Honfleur Harbor
16" × 20" (41cm × 51cm)

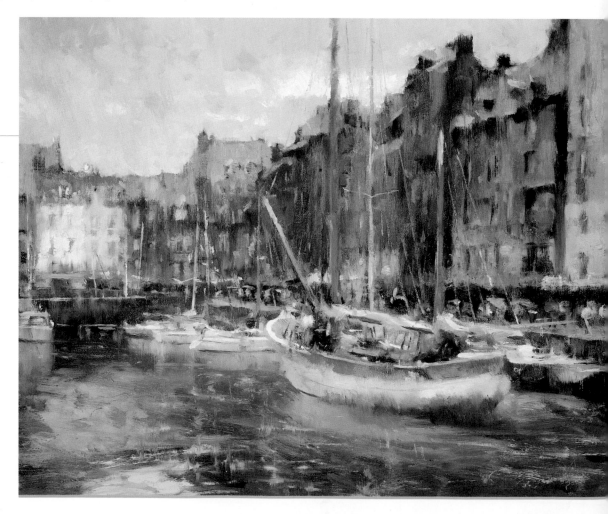

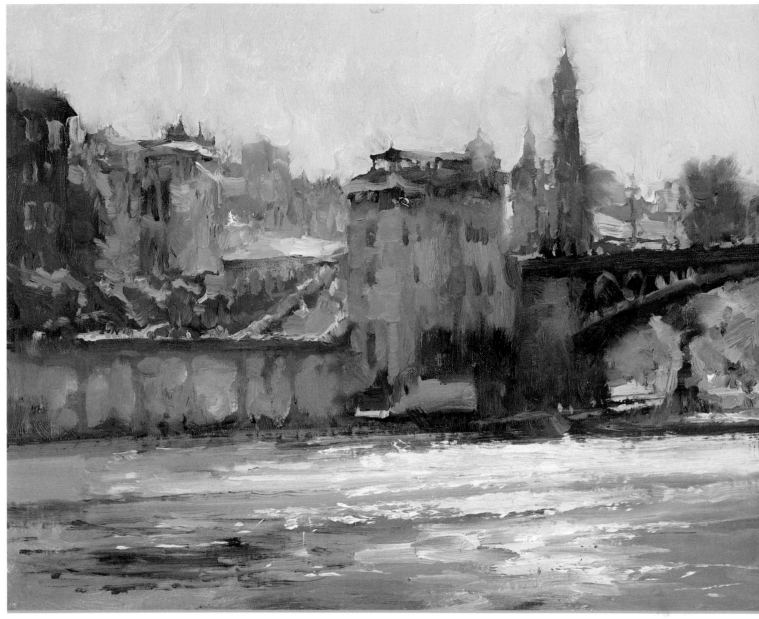

WAYS TO MANIPULATE EDGES

WITH CONTRAST. To make one edge appear softer, you can make another one harder, or vice versa. The more contrast between shapes (contrast of value or color contrast) will give the illusion of a harder edge. Reducing the contrast will soften the effect. Adjacent shapes of similar value or color will create a softer appearance, even if the edges themselves are crisp. A very contrasting value shape or very contrasting complementary color from shape to shape will appear hard-edged due to the natural contrast, even if the edges are quite soft.

WITH THE APPLICATION OF PAINT. You can physically soften an edge with a brush or even a finger. A palette knife can create a razor-sharp edge.

WITH A TRANSITIONAL SHAPE. If you want to soften an edge, you can mix up a pool of each shape color and mix them together. Then lay a stroke in between the shapes, will make the transition between them more gradual.

THE THEORY OF RELATIVITY

The reddest red is at the focal point, as are the sharpest edge and the strongest value contrast. Think how important the theory of relativity is: If I had used my reddest red for the distant awnings, I would not have been able to make the focal point color note any redder. That would have worked against my desire to establish the boat as the focal point.

Mooring Partners
20" × 30" (51cm × 76cm)

1 Lightest light
2 Darkest dark
3 Reddest red
4 Sharpest edge

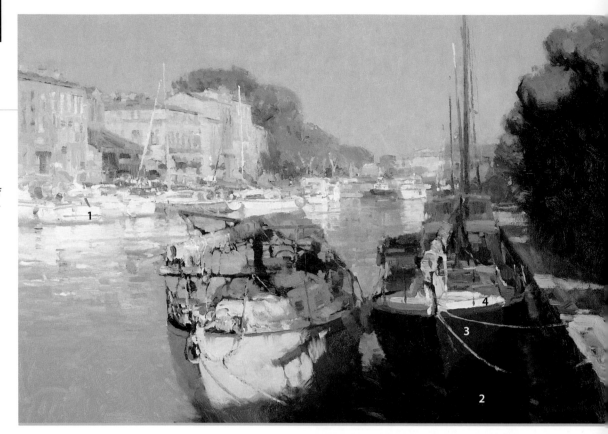

Remember: The colors, values and edges available to us as painters are but a small subset of those found in nature. Painting is not a task of matching nature's colors, values and edges. Rather, you must first determine how you would like to key your painting (somber, bright, pastel) and then transpose the spectrums of colors, values and edges in your subject to the ranges of colors, values and edges you are able to create on the canvas.

1. FIND THE EXTREMES

Whether you're considering shapes, colors, values or edges, your first task is to find the extremes and how they relate to everything in between.

SHAPE: smallest/largest
COLOR: most intense (purest)/most neutral
VALUE: lightest/darkest
EDGES: sharpest/softest

2. RELATE EVERYTHING TO THE EXTREMES

Decide what elements of your scene ought to be given the extremes of your artistic vocabulary. Then decide how the other elements relate to those extremes. Every artistic move you make must live within and be correctly related to the extremes.

3. ADJUST AND CORRECT

As you evaluate and adjust your choices, remember that there are two ways to adjust any relationship. If you think one shape of color in your painting is too dark (or too warm, or too hard-edged), consider whether in fact something else in the painting needs to be darker (or warmer, or harder-edged). The shape that seems not to be working may in fact be the correct passage.

See everything in terms of relativity: relative color, shapes, value and edges.

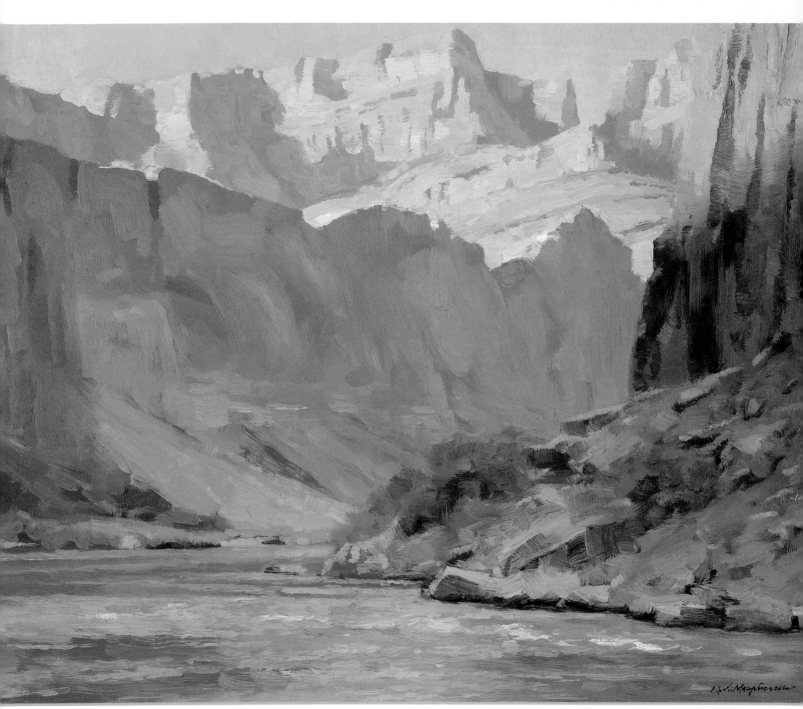

LOOK FOR CONTRASTS OF COLOR TEMPERATURE

Although the light family and the shadow family in this painting are distinctly different in value, close inspection reveals small differences in color temperature as well. These warm and cool variations make the painting more interesting than if the lights and shadows were distinguished by value alone.

Eminence Break
18" × 22" (46cm × 56cm)

4

An aesthetic arrangement has infinite possibilities. There are many principles for successful painting design, but if each was to be followed to the letter, many of the world's greatest paintings would be deemed failures.

Know the rules; learn the basic principles. When an arrangement doesn't work, check the proven guidelines. But also strive to make the unexpected work. Make the painting your own. Trust your intuition.

Painting demands decisions:
your questions and your answers.

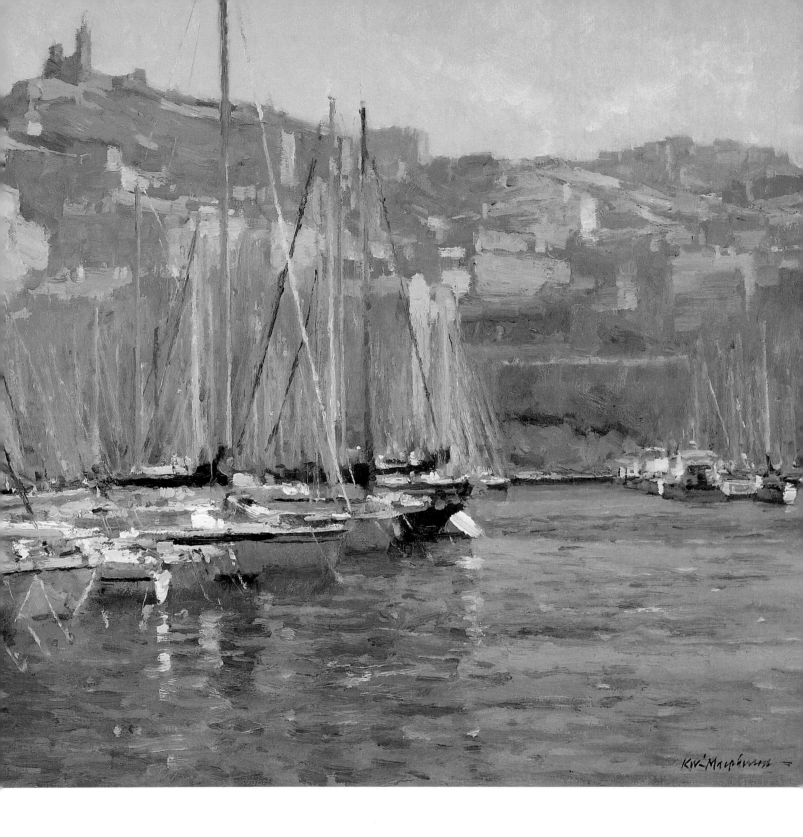

A good painting uses the visual vocabulary poetically. You must arrange color, value, shape, size, linear direction and texture aesthetically, editing the elements of a scene into their proper hierarchy of importance according to the idea behind your painting. Don't place shapes accidentally as they appear; place them purposely as you please, in an arrangement that possesses the following qualities:

UNITY. Unity means that no color, shape, position or value has meaning without the others. There will be opposing forces—sun and shadow, good and evil, big and small—but unity means that the dominant idea always prevails. The presence of contrast actually reinforces the idea.

VARIETY. Variety stimulates interest. An arrangement without variety is boring. A painting needs contrasts of value (light/dark), color (warm/cool, bright/muted) and shape (large/small). Just as the plot in a work of fiction must have conflict, visual art must have contrasts. The deliberate addition of tension gives the visual story its vitality.

REPETITION. Repeated lines, shapes, colors, values and edges tie a painting together. Too much repetition, though, becomes monotonous.

HARMONY. Harmony is a bridge. Common attributes, similar colors, gradations and transitions enable repetition and contrast to live together.

Evening Patterns at Nankoweap
20" × 20" (51cm × 51cm)

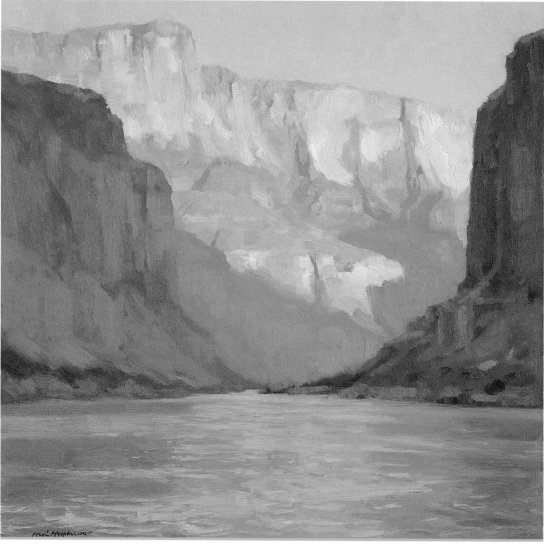

Painting is opposites: light and dark, warm and cool, rational and emotional.

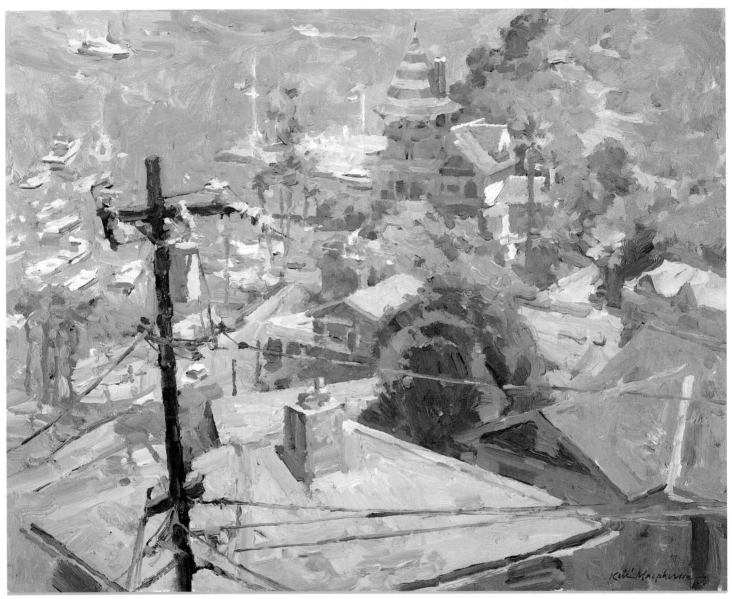

A COMPOSITIONAL DEVICE

I easily could have omitted the telephone pole and wires in this scene. Instead, I used them as a strong vertical and spatial divider. The telephone pole leans slightly to the left. This slight angle is more interesting and powerful than a repeat of the vertical side of the canvas. The dark pole adds space to this very complex scene.

Catalina Rooftops
16" × 20" (41cm × 51cm)

Don't just copy the line of a mountain;
emphasize the qualities of the mountain that give an impression of steepness.

A good painting starts with an idea: what made you want to paint the subject, what you want to communicate about it. "Design" is the series of decisions you make about space, color, size, texture, edges, line and direction, orchestrating all of those in a way that supports the main idea.

CHOOSE A CANVAS SHAPE

As soon as you pick a particular canvas, you have already made an important design decision: the proportion of length to width. This is important because all lines in a painting relate to the picture's edges. A tall, skinny rectangle will dictate different lines than a more balanced rectangle or a square.

DIVIDE THE CANVAS

How you divide the canvas shape will greatly affect the picture. Dividing the canvas with unequal yet balanced proportions is usually more successful than symmetry.

LOCATE THE CENTER OF INTEREST

Decide what the center of interest will be and where to place it. You want to divide shapes and spaces unequally to keep the design more dynamic, so it is best to place the center of interest away from the mathematical center of the canvas.

CHOOSE WHAT TO INCLUDE

Nature is complex; everything you see is not necessarily going to make the best painting. Arrange and rearrange nature components. Pick and choose what is important; what is not, leave out.

PLAN THE DISTRIBUTION OF SHAPES

Consider the aesthetic spatial order: How do your choices relate to your idea?

PLAN THE DISTRIBUTION OF VALUE AND COLOR

Poetic expression includes reducing the elements, tone, color, brushwork and shapes into the most concise answer.

IMAGINE THE POSSIBILITIES

When I am in the presence of a subject, I mentally frame the scene as if with a viewfinder, imagining it as a framed painting on a wall. In the back side of this New Mexican church I saw a more inspiring relationship of shapes than in the more obvious frontal view.

La Santisima Trinidad
18" × 24" (46cm × 61cm)

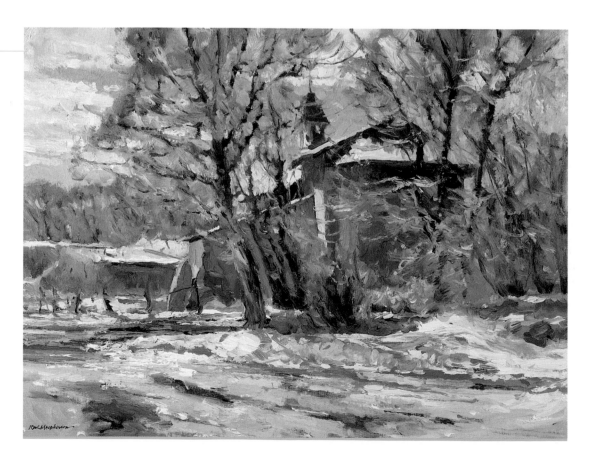

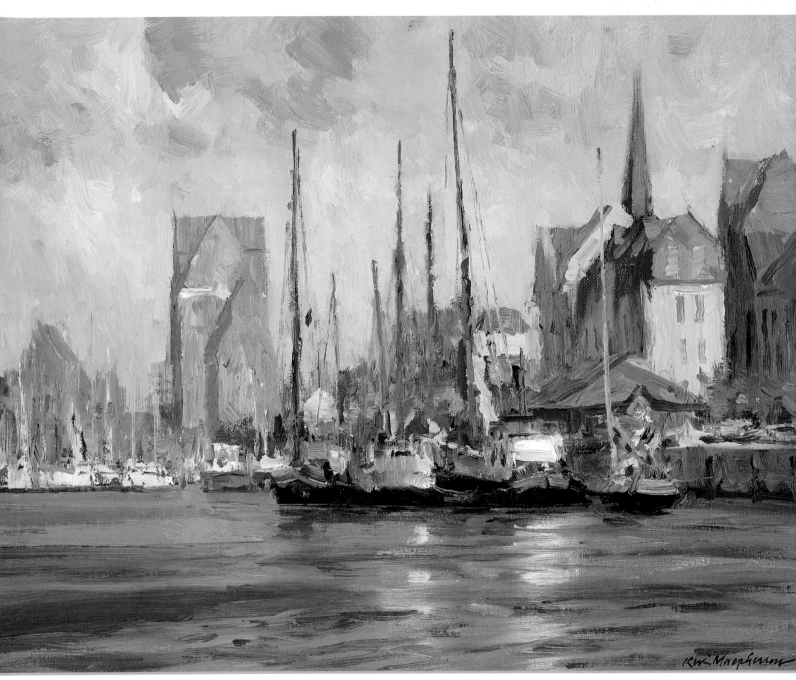

AN ORCHESTRATION OF LINE AND DIRECTION
Although this painting has a horizontal format, I chose to accentuate the verticals throughout the composition. The buildings, the masts and the spire all reach for the sky. The brushwork follows the clouds as they grow upward. All this vertical thrust is complemented by the quiet horizontals of the water.

Rostock, Germany
10½" × 13½" (27cm × 34cm)

Musicians do not record nature's sounds; they translate feelings
about nature into musical notes. Likewise, visual artists do not
mimic reality but translate it into a visual vocabulary.

Time spent doing plans on a small scale is time well spent. Planning prepares you for the visual problem-solving ahead and helps you avoid time-consuming missteps as you paint.

LINE PLAN

A line plan, done with pen or pencil, establishes the placement of major shapes, their rhythms and their linear directions. For example, you might have a diagonal that seems to move the viewer's eye along

VALUE AND COLOR PLANS
In my pen study, I began to establish values. Then I proceeded to a color plan, assigning colors to the values already established.

too fast. A line plan lets you find ways to slow it down, perhaps by overlapping verticals or through the handling of edges and value contrasts.

BLACK AND WHITE PLAN

A black and white plan (shown on page 61) can be done with a marker. Your goal is to reduce the scene to two values: solid black for the shadow family and pure white for the light family. This easily describes the light and shadow pattern. Make the two shapes unequal in size. It doesn't get any simpler than this, yet a black and white plan is very descriptive.

VALUE PLAN

A value plan simplifies your complex scene to just three to five values, including pure white and pure black. You can do the value plan with oils: white, black and three grays such as the Gamblin grays described on pages 12–13. You can also use gray markers, soft pencil or even crosshatched pen.

Simplicity is strength. A complex scene reduced to the most powerful simple values will engage a viewer from across a room.

COLOR PLAN

Do color plans on paper or a canvas pad with oils or gouache. The plan is not a complete painting. Create a very small study with areas of flat colors representing the big shapes of the scene. This study becomes your guide for the quick lay-in of a larger canvas.

LINE PLAN
A line plan helps you establish shapes, rhythms and linear directions. It can also simply get you familiar with the subject.

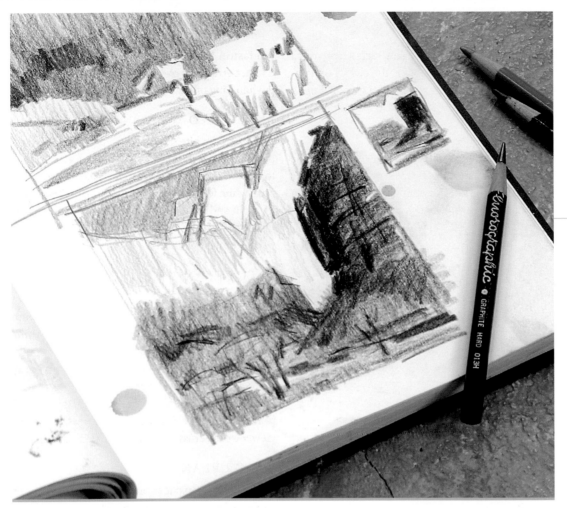

PENCIL SKETCHES

A sketch in soft pencil can sum up your line plan and indicate key value arrangements. Keep all these plans small.

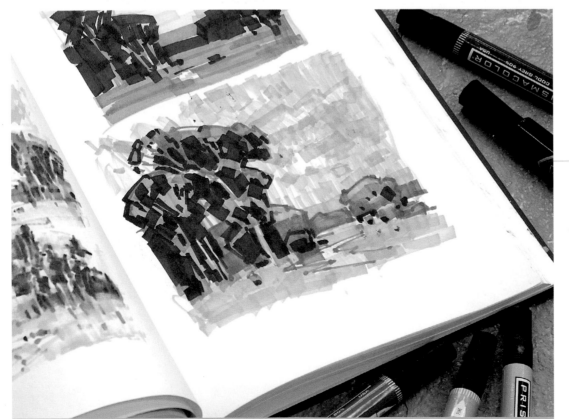

GRAY MARKER SKETCHES

Here I use gray markers to plan my values. The painter speaks with shapes rather than lines, so a broad-tipped marker is best for planning a painting. Fine-tipped markers are better suited for the linear language of drawing.

steps in the painting process

It's fine, even desirable, to mix up your routine so as not to become too formulaic, but these are the basic steps that you'll need to address every time you paint.

1. TAKE NOTES ON YOUR SUBJECT AND WHY YOU WANT TO PAINT IT.

Record your first impressions in a sketchbook or notebook. What are your feelings about the subject? What is your reason for wanting to paint this scene? Write down one feeling. This will help you make the decisions of what to edit out and what to emphasize.

2. ANALYZE THE SCENE.

Analyze the scene you've chosen to paint and find shapes, colors, harmonies, values, lines and rhythms that best reflect the feeling you recorded in step 1.

3. DIVIDE THE SCENE INTO LIGHT AND SHADOW.

Mentally divide your subject into just two shapes: a "light" shape and a "shadow" shape. Sketch the shadow shape with a thick black marker on white paper, and fill it in with solid black regardless of the values or colors within the shadows. (On a gray day without distinct light and shadow patterns, you may have to divide your scene according to obvious large contrasting shapes rather than light and shadow.) For a stronger, simpler design, connect the light shapes, and do the same for the dark shapes.

4. PAINT THE DARKEST DARK.

The darkest dark in your scene will most likely be a shadowed area that receives minimal reflected light. Mix a color of an appropriately dark value and paint the shape of the darkest dark. Remember, it is not necessarily black.

5. PAINT THE LIGHTEST LIGHT.

The lightest light in your scene may not be pure white. Determine its value and flavor. Mix the right color and value, and paint the shape of the lightest light.

6. PAINT THE SHADOW FAMILY.

Break down the remaining shadow area into its largest obvious shapes, values and colors, and paint them, comparing all these shadow colors and values to the

As you are painting, keep the following in mind:

- Maintain the feeling you recorded in step 1; do not chase others that might pass through the scene as you paint. If you were telling a story, you would not confuse your listener by changing the story midstream.

- Seek to create a simplified poster of your scene, the best possible representation of color and shape. Paint simplified shapes with color and value correctly related before concerning yourself with less significant changes. If you look too long at the parts, you may lose sight of the whole.

BLACK AND WHITE PLANS
I analyze my studies or reference photos carefully to decide what the division of light and shadow families should be.

darkest dark. This will help you see how much light is actually within the dark patterns. Maintain the integrity of the shadow shape in the black and white marker study you did in step 3.

7. PAINT THE LIGHT FAMILY.

Break down the remaining light area into its biggest obvious shapes and paint them, comparing all other light colors and values to the lightest light. Remember the black and white cow lesson on page 35: All the values in the light family will be lighter than the ones in the shadow family.

8. CHOOSE YOUR COLOR NOTES.

Look at the subject for one second, then look away from it. React to your first impression. Trust your impression of the color. If you stare too long into the scene, the colors and values can start to bleach out from overanalyzing.

9. EVALUATE.

Now look again at your painting. Did you stay true to your original reason for painting this subject? Did you cement the idea within the colors and shapes you painted? If it needs improvement, correct and rework, painting wet-into-wet.

You are the director of a play. Pick the lead in your visual play.
Direct the supporting cast and remove extraneous players.
Do not take the limelight from the star.

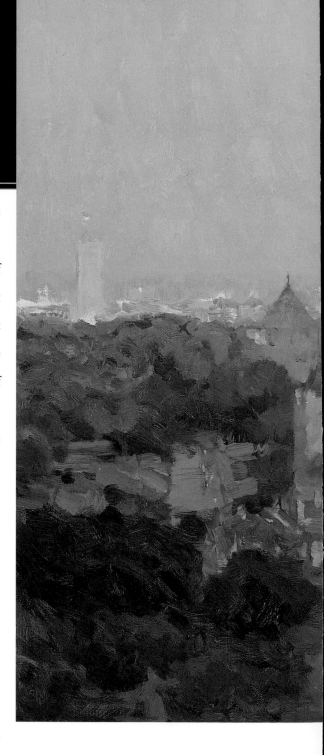

5

PAINTING OUTSIDE

My favorite studio has perfect light, countless subjects and endless space. It is the great outdoors.

Capturing the beauty and the totality of the moment is always a great challenge. The most beautiful effects are often short-lived. One must respond to the scene with both academic knowledge and an emotional response. Engaging both sides of your brain in this way is not easy, but the combination of academics and emotion brings one closer to creating lasting, satisfying art.

Leave the darkness of the studio,
armed with a colorful palette,
to reveal the brilliance of the outdoors.

63

Painting outdoors is a stimulating sensory experience. This surely brings out a more emotive response than being in a studio. Viewers will sense your heightened emotional response in your art.

Let your senses respond to the moment. Record your emotions with a vocabulary of color. What mood has the scene put you in, and what qualities do you want to pull from it or edit out of it? Let this conversation with nature direct your brush. Ask your subject questions about the relationships of proportion, color, values and shapes. Work passionately to seal this moment on your canvas.

Some people, when outdoors, talk to themselves or to animals. One could also talk to trees, light, and the air. It's okay to talk out loud (committing to your questions and answers) while you paint. Passers-by will see your artistic idiosyncrasies as signs of genius.

Sydney Streets
10½" × 13½" (27cm × 34cm)

Qualities of Outdoor Paintings

Plein air paintings typically have a "painterly" quality, meaning they are not laboriously rendered. This looseness conveys the spirit of an artist interpreting the outdoors. Collectors can sense the artist's joy and almost relive the artist's thought process.

Loose, painterly painting is by no means sloppy. On the contrary, it involves selectivity and an underlying excellence in drawing. A painterly stroke reduces many details to a poetic brush mark that expresses more with less. Objects are revealed with spots of color. The quick application of paint is largely due to the speed necessary to capture fast-changing outdoor conditions.

Echoes of Yellowstone
6" × 8" (15cm × 20cm)

Paintings in a small format, such as 6" × 8" (15cm × 20cm) or 8" × 10" (20cm × 25cm), are called *pochades*. There are many advantages to painting small outdoors:

- Working small takes less time, yet offers the same problem-solving challenges as would painting a large canvas that requires more commitment of time and materials.

- You can capture an entire scene quickly in one plein air session. With a large canvas it may be physically impossible to complete a plein air composition in one session. It is not always possible to revisit a site at the same time of day multiple times, and one's mood can vary significantly from day to day, making it difficult to retain the initial motif.

- Painting on a small scale will propel your growth more quickly than painting large. Even though a painting is small, its visual problems must still be solved; you can "solve" ten to twenty small paintings in the time it would take to paint two or three

large ones. Painting over one thousand 6" × 8" (15cm × 20cm) paintings over the course of fifteen to twenty years helped my art evolve to where it is today. Growth comes from experience—lots of it.

- You can commit small windows of time to different subjects or different atmospheric and lighting effects. Painting a plethora of nature's moods and effects adds to your visual encyclopedia.

- Because no one painting represents a huge investment of time or materials, you will find it easier to move forward to new challenges instead of feeling compelled to rework large, problematic paintings.

- Painting at a small size forces you to simplify the many details of a scene into the most important larger shapes and to correctly relate the major shapes without being distracted by details.

- When you are back in your studio, your small outdoor paintings can help you relive the outdoor experience and paint larger works that are inspired and informed by them.

What Brush Size to Use for Pochades

Don't think that working smaller means you must use smaller brushes. Using too small a brush will cause you to think about details too soon. For a 6" × 8" (15cm × 20cm) canvas, try a no. 6 or no. 8 filbert. With practice, you will be able to make shapes ranging from large to very small and narrow with just this one brush.

React in the field; reflect in the studio.

When you look for subjects to paint outdoors, you will be confronted with nature's overwhelming visual chaos. Resist the temptation to put everything you see into one painting. Perhaps three different paintings would be better.

Be open to any opportunity that may reveal itself. Plein air painting is most often associated with pristine natural landscapes, but you can enjoy the challenge of painting anything that puts air and light between you and your subject, be it trees, people, flowers or architecture. The challenge is to capture the qualities of atmosphere and light and how they affect these elements.

HUNTING FOR SUBJECT MATTER

To search for a subject, you might drive or hike an area. At some point the ingredients of a scene will combine into an event that stirs your need to capture it on canvas. Open your mind to these stimuli. On different days you will respond differently, even to the same scene.

Creating a painting may take only two or three hours of actual painting, but you could travel for days to find the inspiration. Your attention will dim if you hunt endlessly; don't procrastinate so long that you dampen your spirit. Painting frequently will sensitize your mind to visual stimulation and make it easier for you to find subjects.

Your choice of subject matter will change over time. When you feel you have finished with a subject, move on to new interests. Don't limit yourself, your subject matter or your audience.

USING A DIGITAL CAMERA TO SCOUT FOR LOCATIONS

Keep a camera at hand always so that you can capture little moments or activity that would be valuable as reference material later.

You might dedicate some days to using your camera to look for future painting locations. Once you are in the presence of a subject, walk around the scene. Shoot many different compositional choices to increase your chances of catching the best angle. Review your picture choices before committing to your final painting location.

Digital cameras allow you to shoot with abandon without worrying about the cost of film. I might take fifty shots to get one interesting arrangement of passing figures. I may never look at the photos again, but I'd hate to lose the chance to get that one great shot.

Some cameras can change the image on the viewfinder screen to black and white or even posterized effects. This can help you analyze a scene quickly, and simply. Seeing the small-scale, two-dimensional view of a scene is like getting a head start on a preliminary color study.

REFERENCE PHOTO:
ST. PIERRE DE MAILLE
This photo offer several possible compositions. You could crop the photo to a vertical, horizontal or square format. The center of interest could be the building, or it could be the ducks in the foreground. When scouting for locations with your camera, take plenty of photos from different vantage points so that you can consider all the possibilities.

SETTING UP YOUR EASEL

The best place for your easel is in a shaded but open area, where indirect skylight fills the shadows with secondary light. You can either shade your canvas and palette with an umbrella, or turn your canvas away from the sun so that the canvas casts a shadow across your palette. You'll need to reposition your arrangement as the sun moves through the sky.

Bright, direct sunlight reflecting off your white canvas and palette surface will reduce your ability to judge the actual value and saturation of your color mixtures. This intense light will fool you into painting darker. Conversely, setting up below the dense shade of an overhanging tree can do just the opposite, causing you to lighten all your colors too much.

Set up your easel so that it is level from side to side. Keep a small bubble level in your paint box to check the levelness. Uneven ground may trick you into painting horizon lines that slide off the canvas.

HOW TO APPROACH THE CANVAS

First stretch your body, the way you would before a workout. Then assume an athletic stance. Whether you sit or stand, do not cower before the easel; approach the canvas with energy and enthusiasm. I prefer to stand. My legs get a real workout; the ground below me gets mashed by thousands of frontward and backward steps.

HOW TO COPE WITH FAST-CHANGING CONDITIONS OUTDOORS

Sunlight might remain fairly stable for perhaps three hours at most. After that, most all the color relationships in a scene will change. You can develop certain skills to cope with this.

SPEED. The first and most obvious solution to fast-changing outdoor conditions is to learn to paint faster. I usually allow my students one hour to complete a scene. They all protest that I'm being unfair (in fact, they usually lose five or ten minutes doing so). But it never seems to fail that although I give them an hour, nature decides to give them even less. Invariably, a large cloud pattern will cover all the sunshine, leaving them only twenty minutes to get the big picture.

Along with speed must come accuracy. Painting fast does not mean sloppily. Paint as fast as you can while still being accurate. Attack the fleeting objects first, such as moving light, moving people, boats or animals.

ANTICIPATION. You can also learn to anticipate what will change soonest, and paint those things first. Perhaps a fast-moving shadow is going to affect your subject more and more as it changes. Or maybe your scene includes people who are going to leave soon. Analyze what areas need to be addressed, placed and committed to early. Plan your attack.

MEMORY. At first it is hard to retain fleeting images in your mind, but with practice your mind will become better able to retain visual recollections.

Even though nature changes rapidly, it's okay to take half an hour, three hours or three days to finish a painting. You can revisit the site another day or finish the painting in your studio. A painting must stand on its own regardless of your methods. A painting done outside is not automatically good; one completed in an hour is no less a work of art than one that was belabored for days. Quality is the bottom line. With practice, you will be able to paint faster and draw more upon your skills of anticipation and memory.

Exercise

Set aside a couple of hours and try painting the same scene three times on three different same-sized canvases. First allow yourself one hour to finish the painting, then half an hour, then fifteen minutes. Doing these sprints will help you learn to paint faster, which is an essential skill for outdoor painting.

Nature controls the light. Release control to nature, and you will see aesthetic arrangements you could not have imagined.

TEN OUTSIDE PAINTING CHALLENGES

DAY 1: STRESS THE ACADEMICS

Choose a plein air subject and paint it, giving careful thought to the following:

- **DRAWING.** Work to get the shapes and their proportions accurate.
- **COLOR.** Choose harmonious colors that evoke the mood of the scene.
- **VALUES.** Assign values that create a realistic representation of the light and a pleasing composition.
- **EDGES.** Edges between shapes can be hard or soft. You can soften an edge by tickling it to blur it or by creating a small transitional shape between the two larger shapes. Use edges to enhance the atmospheric and physical qualities of the object the silhouette represents.

 LESSON LEARNED: A successful painting starts with good fundamentals. Perfecting your skills frees your mind to respond emotionally to your subjects.

DAY 2: PAINT WITH PASSION

Paint the same subject as you did on day 1, except this time go with your emotions. You will remember a lot of yesterday's problem solving; the academic exercise and process will be with you as you react more intuitively this time. Don't worry about getting it perfect, but make sure the viewer feels your passion.

 LESSON LEARNED: A technically correct painting that lacks passion is not art. With practice, you will be able to meld technique and passion into a pictorial statement academically correct and alive with individuality.

DAY 3: DO A ONE-HOUR PAINTING

Paint faster than you are accustomed to painting. Complete an entire 12" × 16" (30cm × 41cm) canvas

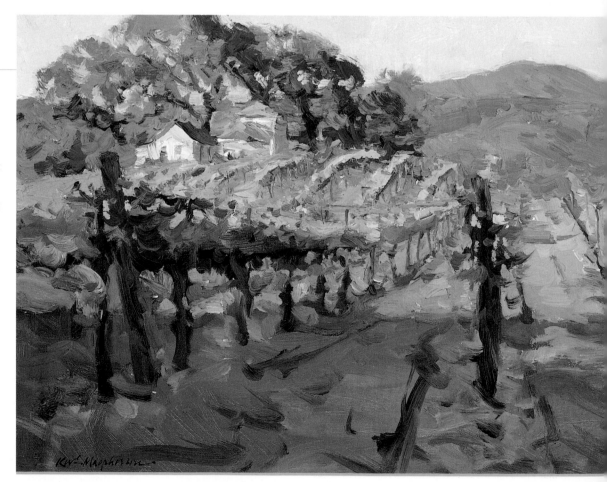

A MARRIAGE OF TECHNIQUE AND PASSION

The light was moving fast, so I jumped right into masses of color for this study, capturing the color in an explosive way. Had I taken the time to draw my placements first, the light effect that so intrigued me would have been long gone by the time I got to choosing color notes. I needed to establish color quickly, trusting that my academic drawing skills would be there.

Rolling Vineyards
12" × 16" (30cm × 41cm)

in one hour. (If you want to paint even larger than that, go ahead.)

LESSON LEARNED: When you paint quickly and intuitively, you have a better chance of capturing the moment. Work too long, and the light will change. Also, when you work fast there is less time between strokes for your memory to fade, making it more likely that your color notes will be related accurately. Imagine playing a tune on the piano with the notes so spread out in time that you forget where you are in the song. Playing the song faster is actually easier.

DAY 4: PAINT TINY COLOR STUDIES

Spend a day doing many tiny color studies no more than 2" × 3" (5cm × 8cm) in size. Each study should be a mini-poster of flat colors with simplified shapes of accurately related color and shadow. Paint them, using as large a brush as you can, with oil or gouache on paper, canvas board or canvas paper. Keep it simple! Don't be precious or use too nice a surface; these are not finished paintings. They could be plans for many future paintings.

LESSON LEARNED: A small study becomes your guide for the quick lay-in of a larger canvas. Small color studies also let you try a few different compositional arrangements without a great expense of time and energy.

DAY 5: PAINT WITH A PRIMARY PALETTE

Try a painting using three primary colors (or three colors representing primaries) plus white. Examples of primary palettes:
○ Orange (functioning as yellow), purple (as red) and green (as blue)
○ Yellow Ochre, Cadmium Red Light, Black

LESSON LEARNED: Representational painting does not mean copying a scene word for word, but rather translating it into relationships of color and value. All the tube colors in the world will be useless to you if you do not properly relate them. A palette of three primary colors gives you all the relationships you need and is simpler to work with.

COLOR STUDIES

These are my paper sketchbooks filled with color studies. In a small study you are forced to reduce a scene to the most important big facts and relationships. The small study becomes your guide for blocking in a larger canvas.

USE THE LARGEST BRUSH YOU CAN

A no. 4 or no. 6 bright brush (either bristle or sable) makes a nice tool for the small color comps. I seek the most representative color notes (proper val-hues) for my scene.

PRE-MIXING FROM A LIMITED PALETTE
Here I have reduced my range from the usual red, yellow and blue to orange, purple and green, yet I can create a rainbow of color possibilities from this limited palette. Pre-mixing some color choices makes a limited palette less intimidating.

PAINT BY THE POUND
Most students scrimp on paint. Squeeze out more than you think you need, and use it all!

DAY 6: PAINT BY THE POUND

For a 9"× 12" (23cm × 30cm) panel, squeeze out an entire tube of white and half a tube each of red, yellow and blue. Use it all. Make the paint half an inch deep on your painted panel.

LESSON LEARNED: Most students never put out enough paint. The textural differences created by areas of thick and thin paint add variety and interest to the painting surface. Thickly applied paint conveys decisiveness and is actually easier to manipulate than a thin layer of paint (see page 30). Learn to use paint—a lot of it.

DAY 7: PAINT ON A TONED CANVAS

To tone a canvas, cover it with color (any color or multiple colors can be used). Either let it dry before painting, or jump right in. Whatever color you choose, find an area in your scene that is the same color as the tone. Don't repaint this color, but paint around it. Key your painting to this note—that is, gauge other values in relation to it.

LESSON LEARNED: A toned canvas helps set the mood of the work and can expedite the paint process if used correctly. The color of your ground will influence all your colors, which in turn helps create tonal harmony.

DAY 8: PAINT WITHOUT BLENDING

Do a painting in which you model form only with decisive color notes, no softened or blurred edges. Gradually reveal form and gradations with smaller and smaller decisive brushstrokes.

LESSON LEARNED: It is all too easy to blend the shapes in a painting to a muddy, fuzzy mess. Overblending destroys the contrasts. Learn to depend less on blending and more on transitional shapes and color notes. This will lend a more painterly look to your art.

TRY A TONED CANVAS
I think "red" when I think of Chinatown. I covered my whole canvas with bright pure Cadmium Red Light. It was challenging and fun to paint on, and it infused the finish with a sparkling energy just like that of Chinatown.

Chinatown
8" × 6" (20cm × 15cm)

The shadow areas are filled with color, but the light areas were simply painted with a light tube gray with barely any hint of other colors.

Martigues
8" × 8" (20cm × 20cm)

DAY 9: PAINT NEUTRAL SHADOWS AND COLORFUL LIGHT

Do a painting in which the shadows are mainly neutral tones, and the light areas are very colorful. Use Portland Grey Deep for all of your shadows. This will work best if the dominant shape is two-thirds in the light and one-third in shadow, as with a frontal light source.

DAY 10: PAINT COLORFUL SHADOWS AND NEUTRAL LIGHT

Do a painting in which the light areas are mainly neutral tones, and the shadows are very colorful.

Use Portland Gray Light for all of your lights. This will work best if the dominant shape is two-thirds in shadow and one-third in light, as with a backlit scene.

LESSON LEARNED: You cannot have it both ways. All colorful everywhere is not desirable. If you choose to fill your shadows with glowing, brilliant color, you will be amazed at how gray your light areas can be, and vice versa. To make your color really sing, use neutrals to complement and intensify purer color notes.

seven methods for success outside

There are different ways to approach and use the outdoor painting experience. Each has its advantages, and different circumstances may demand different approaches. Try them all.

Challenge

Paint a scene outside. The next day, in your studio, put the study aside, out of sight. Paint the scene from memory. Simplify, improve and embellish.

This challenge will help you engage your memory and learn to use your imagination to enhance your studio efforts. Your memory will serve you well. Trust yourself.

METHOD 1: DRAW, THEN COLOR

Take time before you start painting to draw the scene accurately with a pencil or brush. Don't commit to paint until you are satisfied with your drawing.

ADVANTAGE: This method works well with subjects that must be drawn accurately, such as figures or architecture.

TIP: Even though you did an initial drawing, remember that you can still "redraw" as you paint if you find that is necessary. Do not feel that you must color within the lines.

METHOD 2: COMMIT TO THE COLOR SPOTS, THEN DRAW

"Explode" on the canvas with color, reacting to the color. Then arrange the color into the right places in an additive and reductive, almost sculptural, process.

ADVANTAGE: Color and light are fleeting, whereas the drawing—the objects—will be there long after the light has faded. With this method, you have a better chance of capturing the color harmony and feeling of the moment.

TIP: If your drawing skills are not up to snuff, this method might be frightening. Just remember that after the initial explosion of color, you can organize your passionate application of paint.

METHOD 3: FOCAL POINT FIRST

Attack the focal point of the painting first. For example, paint the head of a figure first, and get it accurate before you move on to the body or the background.

ADVANTAGE: An accurate focal point becomes your reference guide for all the other relationships in a painting. The release of pressure is amazing when you get the focal point done. The rest of the painting process will feel easy and relaxed.

TIP: Try this method when you are painting an active outdoor scene, such as two diners at a cafe. Paint the focal-point figures first (for they may leave), and finish the remainder of the scene after your "stars" are gone.

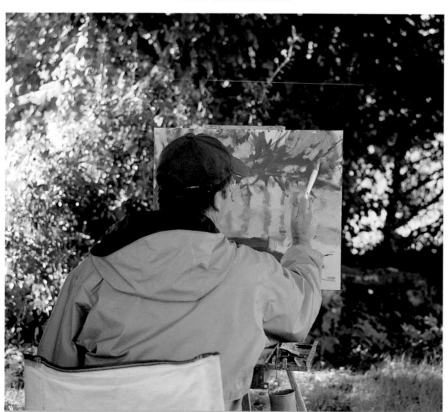

TIP: A few well-placed contrasts of color, value and edges can clarify your idea and focal point.

METHOD 6: BE A HUNTER-GATHERER

Use an outdoor painting session as your chance to gather all the information you can about colors, shapes and values. Try to be true to what you see. Hunt for the very subtly different color notes that represent a certain lighting situation, and pick out the best representative shapes.

Abandon the formulas of studio painting; replace them with direct confrontation with your subject.

ADVANTAGE: Careful observation will train your eye to see the luminous skies, colorful shadows and high-key brilliant colors that exist in nature. This method produces lifelike, natural, finished outdoor paintings. The notes of color, value, light and atmosphere you capture are seeds for future works in the studio.

TIP: The desire to stay true and accurate may cause you to be too literal. Don't worry about making a painting; just seek the information. When you get back to the studio, remember to add your emotions to the final painting and to organize its elements into an aesthetic arrangement.

METHOD 6: PAINTING LARGE: TAKE A SMALL STEP FIRST

On the first day, paint a small outdoor painting. Solve the visual problems and gain a sense of where you are headed.

The next day, paint a larger version of the same subject. Start the large canvas in the studio, using the previous day's study and notes to help you lay in the large surface quickly. Then take the large canvas outdoors and complete it from direct observation.

ADVANTAGE: You'll be able to lay in the large canvas faster than if you had not done yesterday's study.

TIP: Don't be afraid to re-work, scrape down and let go of the study once you are outdoors relating directly to the subject.

METHOD 7: MEDITATE AND PAINT

Go out to your scene with no paint and no sketchbook. For three hours, just look and let your mind respond to the scene. Engage in mental and visual questioning, and experience the scene emotionally.

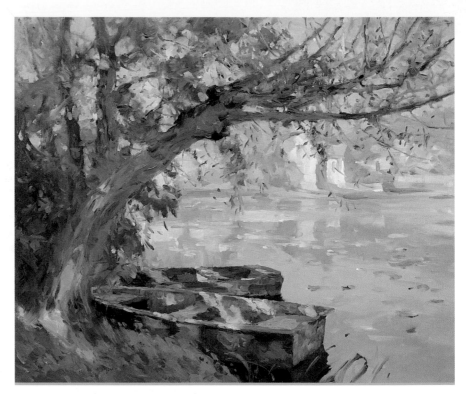

The next day, back in the studio, paint the scene from memory.

ADVANTAGE: This method will help you eliminate the unnecessary details that detract from your visual statement. Your mind will pull out and remember the essentials.

TIP: Do this mental and visual questioning and answering always as you go through your normal daily activities. I have been doing this for so long that it's difficult for me to do or see anything without thinking about how I would paint it.

The earth and sun do not stand still for study. Time is of the essence.

Artists and athletes alike have a state they call "the zone"—that place where your critical mind turns off and you are living in the moment. When I am in the zone, my moments, caressed in the art spirit, feel almost surreal, as if I am watching the process.

I wish I could tell you exactly how to step into the zone. Unfortunately, I cannot, for each person's zone is different. But here are some suggestions.

HAVE A MANTRA. Perhaps music helps you. Or you might have a preparatory routine each time you paint (such as mixing your secondary colors) that gives your mind and body time to slip into a meditative state.

LET DISTRACTIONS FADE. Distractions such as wind, bugs, heat, cold, traffic and curious onlookers pervade the outdoors. On the other hand, the din of traffic can become white noise. One voice chattering can be annoying, but the thousands of voices in a city crowd can be soothing.

TRUST YOURSELF. You know your strengths, your excellence in drawing, your sensitivity to color. You have trained academically, worked in the studio, painted and drawn from the live model, explored values and composition indoors. Believe in yourself. Step into the positive zone so that all negativity fades.

DON'T ANALYZE. Be one with the moment. Be curious and full of wonder, loose and responsive. Instinctively and unconsciously, let your brush be guided by the creative art spirit. Your left brain will be judgmental, wanting to question the art spirit's authority. Judge later. This is as right-brain as you can be.

DON'T WORRY ABOUT WHAT OTHER PEOPLE THINK. I guarantee that anybody, even a beginner, who attempts painting outdoors will impress 90 percent of all passers-by. Just putting up a French easel is impressive. And in any case, you cannot let others' opinions of you become your opinions of yourself.

Painting is hard work and a difficult craft to learn. Don't become so frustrated that you lose the joy that brought you to paint in the first place. Enjoy the whole art process: the mixing of color, how one color reveals its beauty next to another, the smell and texture of the oil paint, the drag of the brush on the canvas—long stroke, short. Feel the breeze and the sun on your face. Feel the joy. This is your job—how great is that?

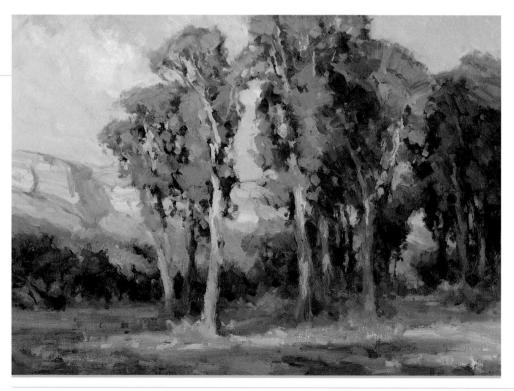

Cottonwood Camp
30" × 40" (76cm × 102cm)

Instinct and intuition take control of the brushes.
Become a spectator to this experience;
enter the zone, a place of faith and trust.

So you have a failure? So what?

I have hundreds and hundreds of failures. The real question is, How can we learn from them? Don't get discouraged.

Relive your process. Where did you go wrong? Were you inspired, ready to perform with a positive attitude? Was the canvas too big, too small? Were you there 100 percent?

Fear can be overwhelming. All artists experience the fear of self-doubt. Don't let it debilitate you. Move forward. If a painting is not working out, redo it or move to another idea. Don't overwork a piece out of a feeling you have too much invested in it. Don't treat each painting as too precious. Have fun and enjoy the process of learning.

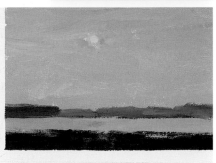
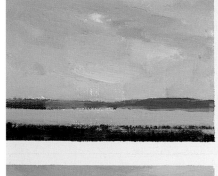

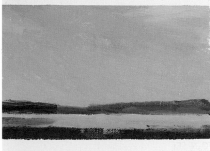

Maintain the "Big Picture"

You might start a painting with well-simplified masses but find that you lose the picture as you refine and work toward the finish. This is frustrating, but the solution is simple.

The start should divide the canvas into the most important value contrasts. Once those are established, refine, modulate and vary the shapes primarily with color (temperature) changes, not value changes. This way you won't destroy the already established value patterns.

NO PRESSURE

To capture this sunset, I taped off six areas on one board and painted studies in sequence, completing each one within ten minutes. This method of painting a fast-changing subject prevents you from overworking each one. Of course, painting that quickly requires you to run on intuition, so the potential for failure is large. Take a chance. Some quick studies will succeed, others won't. Take the pressure off yourself and don't worry about failing.

Irish Sunset Series
20" × 16" (51cm × 41cm)

Paint Outside, *Alla Prima*

Alla prima means all at once. In painting, the term refers to the direct painting or wet-into-wet method. Really, "all at once" can last for an hour or for days; the key is to keep the paint moveable.

Alla prima works best for my temperament. Working outdoors requires capturing fleeting light effects and once-in-a-lifetime locations, so I need to paint with a method that allows me to make a complete statement in one session.

REFERENCE PHOTOGRAPH
The medieval city of Montmorillon in France was merely a silhouette as the sun went behind the structures. The backlighting intrigued me. As I started to paint, only a few rooftops and tree forms were in direct sunlight. I knew this transient effect would not last.

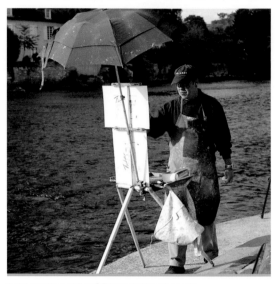

SHADING YOUR WORK SURFACE
I use an umbrella and an extra canvas board on my easel to shade my palette while I work.

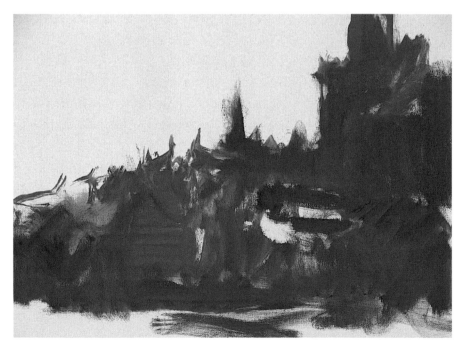

1 Make a Quick Start
Mix a middle-value "mud" made from grays scraped to the side of your palette during a previous painting session. Thin the paint a little with mineral spirits to make it semi-opaque. Use this to block in the overall silhouette of the scene.

This first stage should take only a few minutes. I chose to crop off the top of the cathedral because I thought its vertical shape might command too much attention otherwise.

2 Establish Values

With a mixture of Cadmium Red Light and Ultramarine Blue, block in the darkest darks first. Next, indicate the lightest light areas. Then block in some middle values. Concern yourself only with the big shapes and rhythms for now. In this creative stage, you can wipe off tone with a tissue to rearrange the big picture. You are not yet committed to accurate color or shapes at this stage.

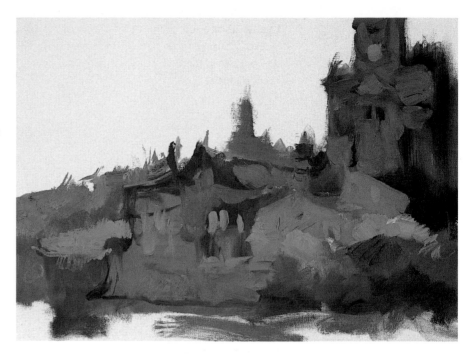

3 Paint Shadows and Enhance Water and Sky

Refine the shadow areas. Observe the various sources of reflected light within the shadows; your eye can see more colors than a camera can. Add a cloud shape to counterbalance the strong, earthy diagonal of the buildings. When a cloud element such as this floats by, grab it.

Work all over the canvas. Use value gradations to merge objects into one another to form unified abstract shapes, but carefully select which color notes and details will remain within these shapes to direct the viewer's eye throughout the canvas.

Make sure the shadow values are not too light so that you preserve the overall large shape.

Paint some sunlight streaks on the water to add to the illusion of space.

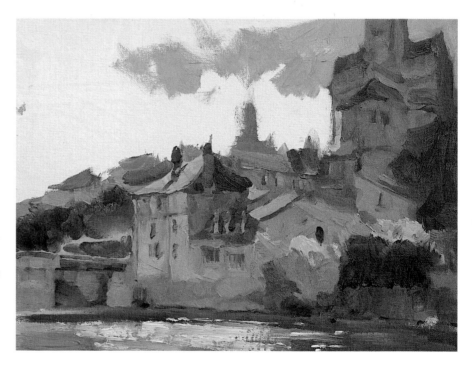

The light moves fast, so you must, too.
Mix colors, ask questions, answer questions rapid-fire.

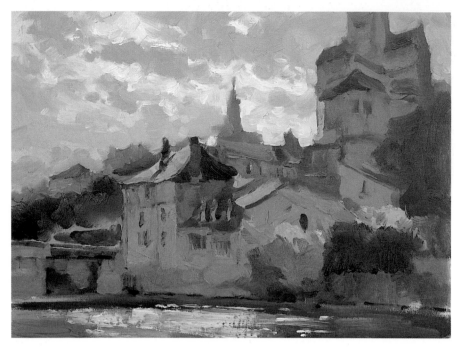

4 Refine

Correct and refine what you've done so far. Seek to unite the relationships of color, value and shapes to make one complete statement. Adjustments are easy when you work wet-into-wet; you can just scrape or wipe off areas back to bare canvas or repaint right over existing paint.

PAINT LARGE, PAINT THICK

I sculpt the paint and shape with a large no. 10 badger hair bright brush. Don't be afraid to put down thick paint. It is much easier to manipulate thick paint as if it were modeling clay when you want to change a shape rather than to move a thin layer of color. Remember, you can always scrape paint off or apply thicker paint right on top. This wet-into-wet layering of thick paint adds to the lusciousness of the color.

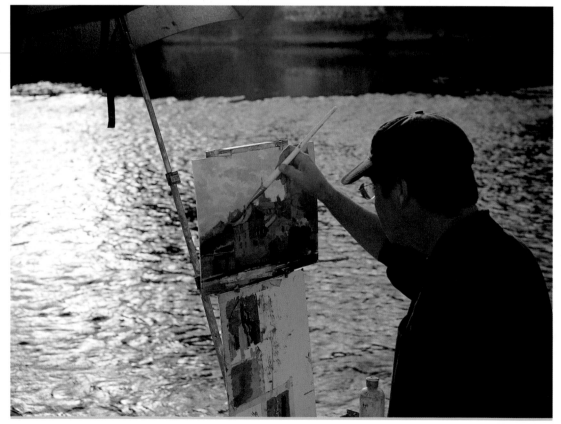

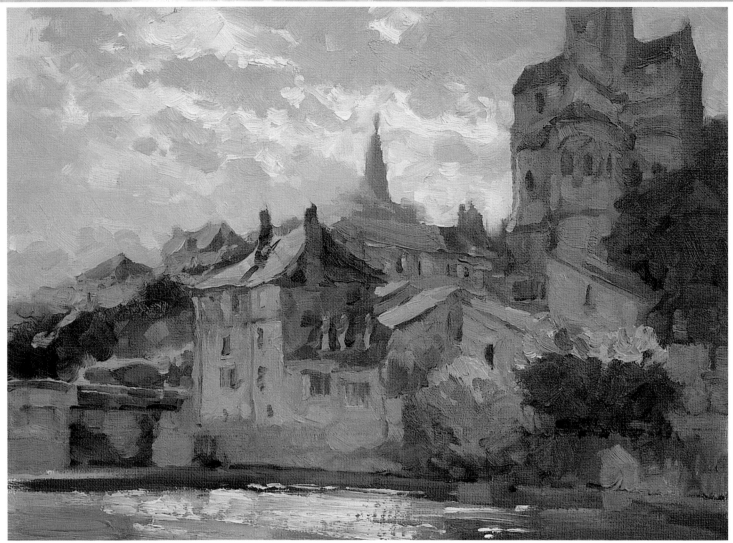

Montmorillon
12" × 16" (30cm × 41cm)

5 Finish

Capture the rim light contrasts in the clouds, which add interest to a relatively large sky area. Refine the contours where the sky shape and the building silhouettes meet. Try to meld dark shapes into other dark shapes; this keeps the painting unified, rhythmic and more organic.

At the point when I put down my brush and feel that a painting is complete, another artist might think it is only roughed in. For me, detail does not say more; the overall expression is more important. This is a personal decision every artist makes for himself.

How to Keep Up With the Fleeting Light

Light changes quickly. If you constantly chase the light and change your painting, your values will be muddied and your original composition will be lost.

To avoid this, establish the shadow pattern first. (Establishing the shadow pattern conversely states the light pattern.) Control the subsequent values so you do not destroy the patterns of light and shade already established. A muddy painting does not have enough contrast because the light and shadow values have crossed their boundaries.

Capture Transient Subjects

Monet set up in the quiet countryside along the River Creuse in France and painted the Creuse Valley many times. As I painted this pastoral area, cows would occasionally appear and tease me to paint them.

Materials

Palette
Cadmium Yellow Light • Cadmium Red Light • Ultramarine Blue • Titanium White

Brushes
No. 10 badger hair

Canvas
13" × 18" (33cm × 46cm)

REFERENCE PHOTO
I took many photos of cows as they moved through my scene. I painted them from life, but references like this one will be useful if I need more information for a larger work in the studio.

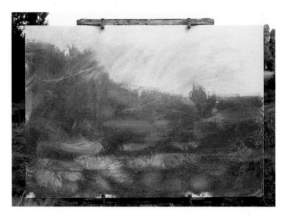

1 The Start

Dilute a mixture of Cadmium Red Light and Cadmium Yellow Light with a small amount of spirits and use this with a rag or the no. 10 badger hair brush to cover the white canvas. With a tissue, wipe away some of the tone to create the contours of the land mass. This first toned shape captures the "big picture." Toning the canvas quickly gets you started, which is sometimes the hardest part.

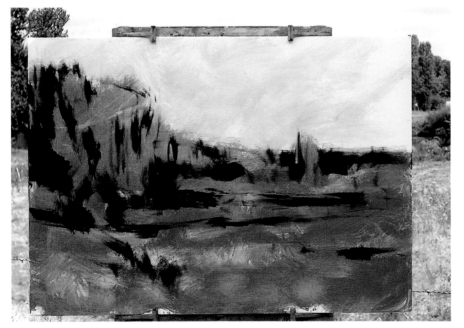

2 Paint Foreground, Middle Ground and Distance

The tone you applied in step 1 represents the general value of the light family. Establish the shadow colors in the foreground, middle ground and distant sections of the painting. The values will be close, but even so, they begin to reveal the effects of atmosphere as the features of this landscape recede into the distance.

3 Choose the Dominant Color for the Sky

Cover the sky with a mauve tone. Rub out color with tissues where the cloud shapes are lighter in value. Choose the most representative color for the sky. On this day the cloud-filled sky contained some blue, but the purple I saw in the cloud masses was the one color that best and most quickly represented the overall sky shape.

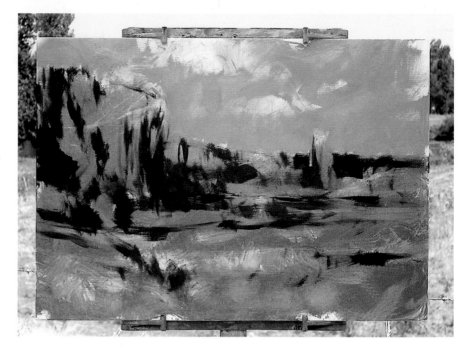

4 Add More Color

The light family in this painting consists mainly of greens. Mix a large variety of greens, keeping their values close and comparing them on your palette. Paint negative shapes of blue to break up the cloud-filled sky.

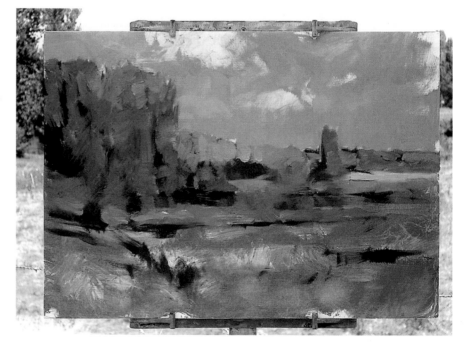

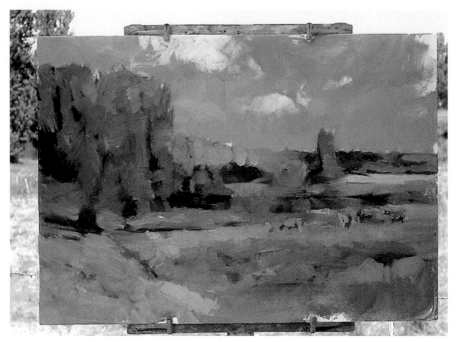

5 The Thrill of the Chase
Add color to the foreground, following your established shadow pattern.

Cows arrived to graze as I was painting. I jotted down color notes to represent them, then added the shadow shapes. I was not concerned with details—these two simple shapes of color are all I need to describe the cows.

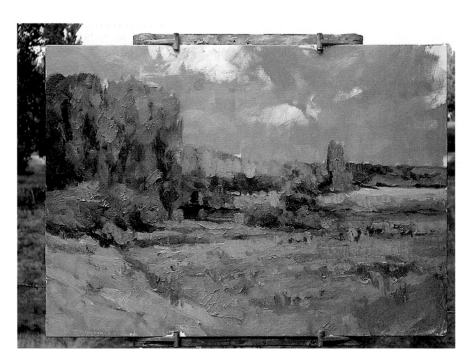

6 Refine With Smaller Shapes
Work over the landscape with smaller shapes of color.

On a partly cloudy day, the clouds' shadows drift over the scene, changing color values and compositional patterns. (You can see this happening on the landscape behind my canvas in these photos.) Remain committed to your established shadow pattern in spite of nature teasing you. If the light has changed so much that you can't judge colors, pause and clean your palette until the light changes in your favor.

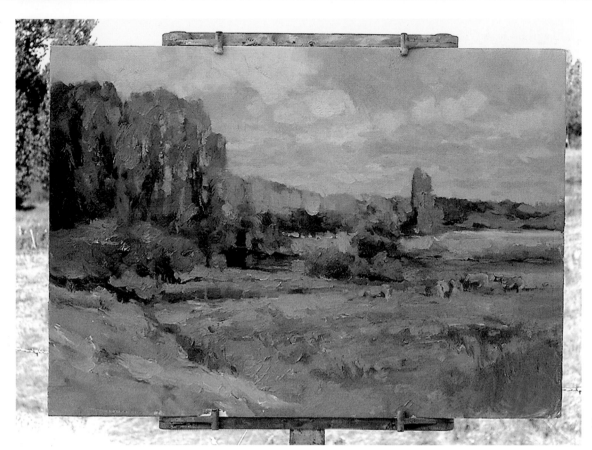

Along River Creuse
13" × 18" (33cm × 46cm)

7 Finish
Refine your shapes and finish without over-working. I paint until the light changes too significantly or my mind gets too tired.

Maintain your original idea in spite of the changing environment.

Paint the Air, Not the Subject

Materials

Palette
Cadmium Yellow Light • Cadmium
Red Light • Ultramarine Blue •
Portland Grey Light • Portland Grey
Medium • Portland Grey Dark

Brushes
No. 10 badger bright • No. 8 bristle
filbert

Canvas
12" × 16" (30cm × 41cm)

Ironically, the outdoor painter's true motif is essentially nothing. That is, we don't paint the subject so much as we paint the air, or atmosphere, around the subject. The air may or may not be clear. Dust, pollution and especially moisture influence the density of this elusive substance.

On this overcast morning, the light was subtle compared to the contrasts created by the sunshine. The skylight, silvery and cool, came from above. This created warm, delicate shadows on the under-planes. Thick veils of fog diffused the depths of space.

1 Rough In the Composition

With light, medium and dark grays, arrange the scene in three major shapes with a no. 10 badger bright.

When I started this painting, the fog made these three shapes quite easy to see, but I knew that fog can lift quickly, so I kept a quickened pace.

2 Tune In the Color

Now, your job is to colorize the tonal arrangement you laid out in step 1. Move around the canvas adding indicative color notes with mixtures made from your primary palette (Cadmium Yellow Light, Cadmium Red Light and Ultramarine Blue) and Titanium White.

3 Adjust the Sky and Add a Light Note

The sky was keyed too dark, so I wiped it away with a tissue. Adjust your sky as needed. As you add more information, try to keep the darks connected. Paint the light glare visible on the distant water under the arch. This light note is an important counterbalance to the weight and diagonal thrust of the massive castle ruins.

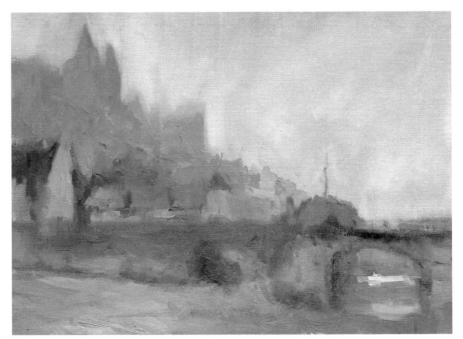

Art is the fine arrangement of graphic elements with selection, omission and exaggeration.

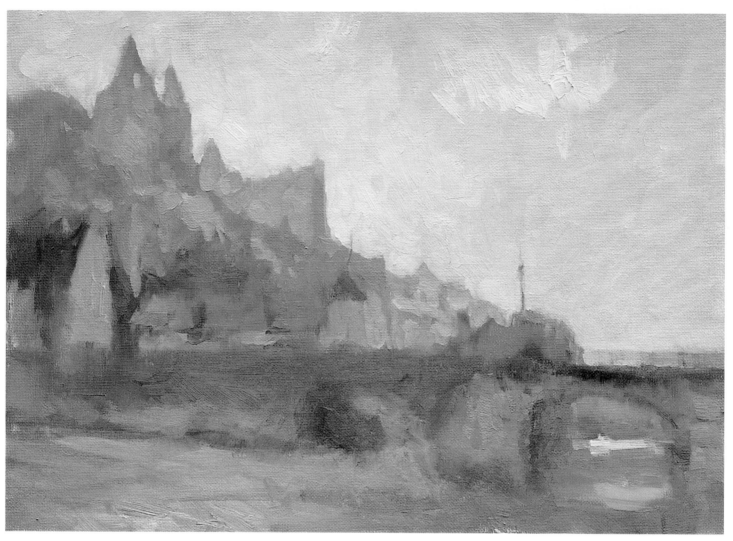

4 **Subtle Solutions**
Refine, looking for all the warm and cool variations of color that describe the forms. This is fun and challenging work. The sun tried to show itself through the haze, which created subtle interest in the large area of the sky. Surprisingly, the color of the sun globe is very cold.

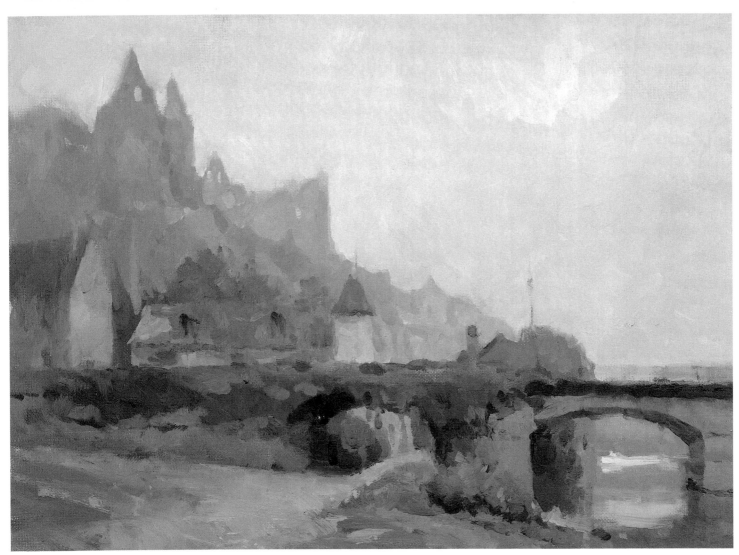

5 Finish
Use smaller color spots to create the impression of more detail. Darken the undersides of the bridge; the added contrast gives the painting a bit more depth.

Don't paint if not inspired. But paint often to breed inspiration.

6

PAINTING INSIDE

Many outdoor attempts fall short of successful, yet possess qualities that can be improved on into a grander statement in the studio. Each truthful color note on a plein air study is a priceless seed of information that can transform your studio work to higher levels. Also, in the studio you can practice picture-making principles and experiment in a controlled environment.

Indoor and outdoor painting are complementary experiences. As memories of nature breathe life into your studio work, the disciplined approaches and principles you practice indoors will enable you to attack the canvas outdoors in new ways.

Your studio time is a time for exploration,
self-development and intense learning.
Take risks; try something new.
Growth will come if you are not afraid to fail.

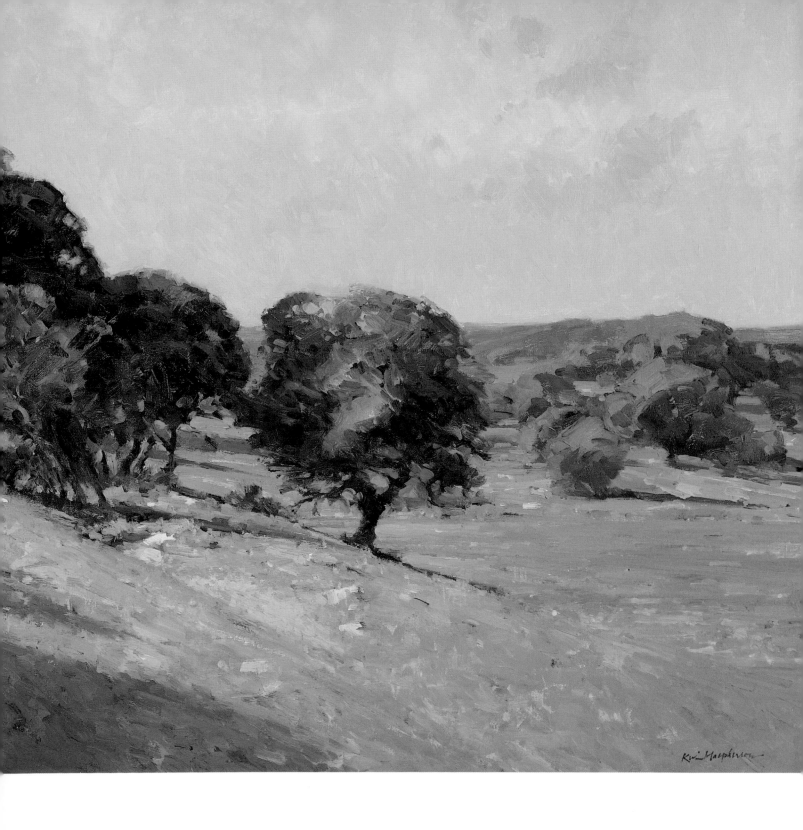

TEST THE COLOR BEFORE YOU COMMIT

Use an acetate sleeve as a quick and painless way to match color notes and test changes to a composition. For example, you can test color choices against a small color study to guide a larger painting to successful completion. Mixing big pools of general color gleaned from the study can expedite your block-in of the larger canvas.

Pros and Cons of the Studio Environment

The studio is a comfortable environment where you have time to practice accurate drawing and other academics.

On the down side, without being in the presence of the scene that inspired you to paint, it is more difficult to open the door to that zone where your responses are more intuitive (see page 74). This may make it tempting to rely on formulaic solutions.

In the studio, surrounded by studies and photos and informed by your memory, try to unite the freshness of plein air painting with thoughtful pictorial design.

After an outdoor painting experience, examine your efforts with a fresh eye. How do they live on their own? Now, away from the actual motif, have they captured your idea? The process outdoors may have been the most pleasurable experience, in which everything just seemed to flow off the brush, but perhaps the product itself has flaws. Remember, just because it was done outdoors does not mean that it is great.

Your studio time is your chance to evaluate an outdoor study, learn from it, and further develop its virtues and fix its flaws on a larger canvas. Your challenge is to retain the vitality, spontaneity and harmony you achieved while painting outdoors, while using your picture-making skills to create a more thoughtful statement. Bringing a study to life in the studio on a grander scale is rewarding.

THE STUDY: TEMPLATE OR DEPARTURE POINT?

Even if you wanted to duplicate the small study on a larger canvas, you probably would not be able to. There is always something special about paintings done on the spot. The struggle and corrective process to get at the finish creates surface layers that defy repeating.

Let the small study be the departure point, the seed of inspiration, just as nature is our inspiration. Don't copy stroke for stroke. Don't be afraid to follow a new direction as the large painting progresses.

CHALLENGES WHEN USING STUDIES AS REFERENCE

As you enlarge your idea, you may realize you do not have enough knowledge or information to work from. On a small canvas, it's easy to solve a visual problem with one stroke, but a bigger canvas requires more information to solve that same problem. If your outdoor study does not contain enough information, go back out and seek what you need via photos, pencil sketches, value or color notes, or additional outdoor paintings.

TIPS FOR PLANNING THE LARGE CANVAS

LOOK FOR MULTIPLE COMPOSITIONS WITHIN A STUDY OR PHOTO. Perhaps you will communicate your idea better if you paint just one area of a larger scene. One reference can stimulate multiple compositions.

BORROW JUST A SLICE OF A STUDY, SUCH AS A COLOR NOTE. Combine this slice with any reference photo or outdoor field study for a new, unrelated scene by

changing the color notes in the reference or study to those found in the color note slice. (See page 129.)

TIPS FOR EXECUTING THE LARGE CANVAS

KNOW THE COLOR AND DIRECTION OF THE LIGHT SOURCE. Outdoors it is easy to determine where the light is coming from; just look up at the sun. However, with a photograph it is easy to misread the light source or forget to look for it entirely. Looking at an area of white objects makes it easier to see the temperature of the light source.

USE THE GRID METHOD TO ACCURATELY SCALE A DRAWING FROM A SMALL STUDY TO A LARGER CANVAS. See the illustration on this page.

PRE-MIX COLOR PUDDLES BASED ON THE STUDY. This makes the lay-in of the large canvas go faster.

BREAK DOWN THE PAINTING IN STAGES SO IT IS NOT SO OVERWHELMING. For any painting, attend to each of the following in this order: drawing, value, light/shade, color, edges and texture.

CAPTURING THE "ALLA PRIMA" FEEL AND LOOK

Painting *alla prima*—finishing a painting in one session—is difficult on a large canvas. One way to capture the alla prima feel is to repaint large, dry areas to refresh the paint so you can continue to manipulate the edges wet-into-wet. Alternatively, you can paint in sections, finishing each quadrant of the painting so it is wet and complete before you go to the next area. With this method, you'll need good studies so you have a firm understanding of where you are headed.

A large canvas can take days or weeks to paint, meaning the surface will be dry long before you are done. To keep yourself in the alla prima frame of mind, start each new painting session in an area of the painting that is less precious so that you have a chance to warm up.

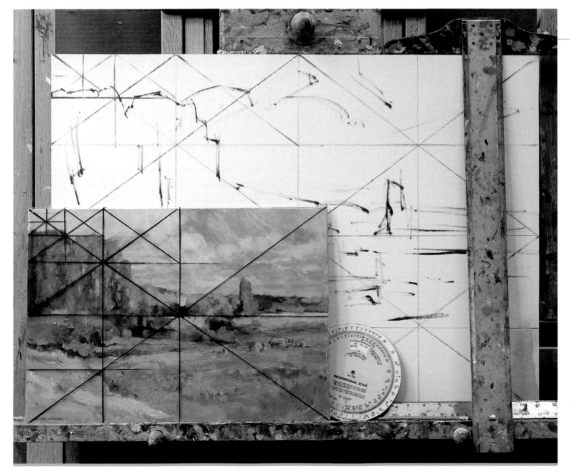

HOW TO SCALE A STUDY OR PHOTO UP TO A LARGER CANVAS

Use a proportion wheel to find a canvas size of the same proportions as your study or photo. For example, a 13" × 18" (33cm × 46cm) study can be enlarged to a 20" × 28" (51cm × 71cm) canvas.

Next, mark a grid on your study (or use a dry-erase marker on an acetate sleeve atop your study) as follows: Connect the opposite corners with an X. Align a T-square with the center of the X and divide the canvas into fourths. Repeat, dividing each quadrant into fourths again, until the rectangles are as small as you need to plot the major points of the drawing.

Finally, create the same pattern of gridlines on the other canvas. Use the lines to help you transfer the drawing accurately.

PHOTOGRAPHS AS REFERENCE

The camera can give freedom to the artist. It's a useful tool, quickly recording fleeting effects difficult to capture through sketches alone. Yet the same tool that opens doors has blocked many artists from achieving growth. Laboriously copying a photograph becomes the goal, to the exclusion of artistic learning.

No photograph, whether it is a print or a slide, digital or not, can represent exactly the same color you would observe from life. However, good-quality film will give you a closer representation. Remember, relationships of color are more important in painting than actual colors, so don't let a photo dictate what colors you will use.

I've long used a slide projector to display my reference photos. They work well, but more recently I've come to prefer viewing digital photos on a computer screen. In a well-lit room, a computer screen is easier to see than an image from a slide projector. Digital photos can also pick up gradations in the lightest and darkest areas of a scene better at times than film can, and a digital photo can be manipulated with image-editing software to display these ranges more clearly.

Rely on photographs for the drawing and the position of objects, but not necessarily for the color of the object. Glean all your color notes from the study, not the photo. I actually prefer to use a poor-quality photo or slide so I am not dictated by the photographic colors. You can even use a photo taken on an overcast day, but create your own sunshine shapes. Rely on your outdoor knowledge.

Each time you take a reference photo, take two extra shots: one overexposed to read into the shadows, and one underexposed to record more information about the light family. (This is called bracketing your exposures.)

WHAT REFERENCE PHOTOS CAN AND CAN'T DO

Copying a photo—even a beautiful one like this—is perhaps a skill, but it is not an art. Representational art uses various degrees of realism, but without selectivity and emotional input it is just a picture.

Reference photos can, however, help you enlarge an outdoor study into a grander statement in the studio. A good photo can supply details that were too small to include in your outdoor study, but which become necessary to include in a larger painting.

Art is human. Imitation without emotion is not art.

Caution: Do not rely on photo information for dark shadow values. You will probably end up with shadows that are too dark in your painting.

Here's a tip for using prints: To get a clear idea what is hidden in the shadows, place the photo print directly in front of a high-intensity lamp. This will "overexpose" the photo and reveal hidden treasures.

PHOTOS VS. OUTDOOR STUDIES

The photographic image has set a standard of representation that many people equate with artistic merit, thinking that if a painting looks like a photo it must be good. This is very far from the truth. A painting is the communion of the artist and the subject.

The camera accepts everything it sees. To copy a photo is to compile facts, not to express an idea. Art must have the human element.

My outdoor color sketches always bring me back to the moment I painted. They enable me to relive the day, the mood and the sensations. Not many photos can do this. I take thousands of photo references, but few stir my emotions or rekindle the inspiration of my travels. And no photo reference can provide accurate, truthful color notes and values acquired from direct observation.

Is it ethical to use a camera? Of course, but to rely solely on photos for inspiration will hinder your growth. I rarely look to the photos unless I am lacking information, and then usually only when a painting is near completion.

PHOTOS VS. DIRECT OBSERVATION

Color in a photo can be either washed out or garish compared to the colors of the real scene. Also, value relationships can be distorted. Shadows are frequently too dark, lights too light.

Camera lenses can distort shapes. A wide-angle lens, for example, can cause straight lines near the edge of the photo to appear to bow outward. Be careful not to transfer these distortions to your painting.

A photo eliminates the human element: the artful selection of compositional elements, the artist's memories of the scene and the feelings the scene evoked.

Copyright Issues

Many artists are not aware that painting from a photograph taken by someone else is copyright infringement. The same goes for painting from another artist's painting. Photos or paintings by others may inspire you to see a subject a different way, but please do not copy them. To do so is illegal. Copying a painting can help you grow as an artist, but the results should never leave your studio.

For your own work, find and research your own subjects, including taking your own photos. Make it your view, your idea.

Art is personal. Paint from life—your life.

MAKE YOUR OWN DIGITAL STEP-BY-STEP DEMONSTRATIONS

Create your own step-by-step painting demonstration quickly with a digital camera. Document each changing phase of your painting. So many times I have had a great start only to slowly slide downhill to a very dull finish. Where did the painting go wrong? Well, by revisiting the sequence of digital photos, I can plot the painting's demise. Use this technique to troubleshoot paintings.

MULTIPLE PAINTINGS FROM ONE PHOTO

Using one photo as inspirational reference, create ten different paintings, each exemplifying different qualities. This could include different crops of the photo as well as different ways of painting the same area. This challenge will help you see more opportunities in any given scene. One photo can stimulate endless paintings if you follow an idea. Here are some painting ideas to choose from:

- Black, white and grays
- High key (pastel)
- Low key, somber (nocturne)
- Pure color
- Red, yellow, blue or green
- Abstract: Use the scene to design shapes, colors, values, lines and textures with no representation of reality.
- Spring, winter, summer or fall: What do these words or seasons evoke for you? How can you change a photo significantly to change the season?
- Negative shapes: Concentrate on this one aspect. Every shape creates a negative shape.
- Pattern: Emphasize the two-dimensional qualities of the scene, making interesting patterns rather than worrying about "space."
- Rhythm: Find and emphasize fluid shapes, lines and colors.
- Tonal: Keep all your colors and values very close.

PAINT A LARGE PAINTING EXCLUSIVELY FROM PHOTO REFERENCE

Photo reference is convenient and at times the only reference available for a subject. Solve the visual problems on a small scale; work out the color choices and value arrangements. Do three or four versions and evolutions. Once you get a pleasing "study," put the photograph aside. Now paint from your studies and imagination. All your outdoor work will serve you well.

Try these additional challenges:
- Do ten 6" × 8" (15cm × 20cm) paintings from one photo reference, letting each one evolve from the previous one. (After the first or second version, put the photo away.)
- Use a set palette of pre-mixed colors inspired by a study or color note slice. Paint a scene from any study or reference photo that pleases you, but restrict your palette to the pre-set color mixtures. The scene you paint need not be related to the source of your set palette: You could use the colors from a canyon study to paint a French street scene.

TURN YOUR WORLD UPSIDE DOWN

Position your reference photo upside down, then paint it upside down as well. When you force yourself to see abstract shapes and not things, you will be able to paint the image as shapes of color in the right places, and your painting will appear almost magically.

Students have been brought to tears of joy in workshops after reluctantly forging ahead with the upside-down process. Do not cheat; do not peek until you can truly say, "I am done." Learn to trust and respond to shape, value and color.

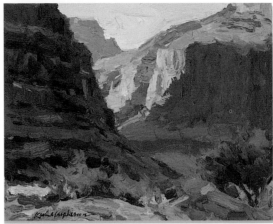

North Camp, Morning
8" × 10" (20cm × 25cm)

USE A SET PALETTE TO PAINT AN UNRELATED SCENE

Your outdoor studies contain a wealth of information. When I painted the canyon study shown here, I found the color combinations intriguing. I used this palette of colors to create a harmonious arrangement with a totally unrelated reference photo of a cathedral.

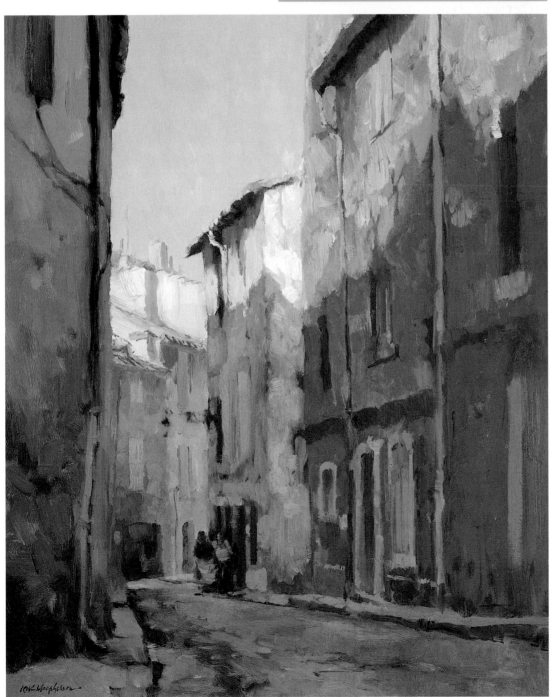

In the Shadows of the Cathedral
40" × 30" (102cm × 76cm)

Representational painters seek beauty (harmony) and truth (according to the laws of nature). How the finished painting appears is a personal translation and will vary according to the degree of imitation used. From highly rendered realism to impressionism and expressionism, the choice is yours. One is not more correct than another.

THE CORRECTION PROCESS

Painting is a series of corrections. One tries to get it right in the beginning, but it is unlikely that one will. Adjust shapes, colors and values until they are correct. Look over your painting and ask yourself if you like it and if anything needs refinement. Let the painting lead you to the degree of finish. When you have no more corrections, you are finished.

FINISHING A SHAPE

To finish a shape, you needn't do very much to the initial lay-in. It is a matter of being more descriptive with the silhouette's edge—perhaps more ornate on this side, simpler on that side; with harder or softer edges. Adding variety to the edges of the flat silhouette finishes the shape.

WHEN DO I VARNISH MY PAINTING?

As we work with thin and thick layers of paint, the thinner layers are more diluted with solvent and the thicker paint is still heavy with oil. The thin layers dry duller while the purer, thicker paint still retains the oily shine. Sometimes this is due to the surface you are painting on. A gessoed panel, for example, really sucks up oil. The result is an uneven finish. A light spray of varnish will bring a more even finish to the painting. However, a painting needs time to thoroughly dry before it can be varnished—as long as six to twelve months. If you don't want to wait, after your painting dries to the touch you can spray it with retouch varnish to even out the surface as an interim step to a final protective varnish.

Varnish can be either an aerosol spray or a liquid that you brush on. Varnish comes in gloss, satin and matte finishes. A gloss varnish gives the fresh appearance of a wet painting, but can create viewing problems due to glare. Matte varnish does not have the problem of glare. Satin finish is a good compromise.

SIGNING A PAINTING
Take care with the color, placement and execution of your signature, for it is your stamp of approval, your guarantee of quality.

I apply spray varnish outdoors, wearing a mask, an apron and rubber gloves to keep the collateral spray from coating me and my lungs. Outdoors, you must be careful to keep bugs and dust out of the fresh varnish.

SIGNING A PAINTING

Your signature on a painting is your stamp of approval. Write your name so that a buyer can easily read it. Be professional; avoid nicknames. If you have affiliations with national painting groups, it is up to you whether to use those letters after your name.

Choose a color and location for your signature that will make it "belong" to the composition. Remember that up to half an inch around the edge of the painting could end up being covered by a frame. Be careful not to make your signature so large that it takes away from the art.

I like to sign a painting after it is dry; it's easier then for the paint to grab and flow off the brush. To do this, thin your paint by adding spirits. You want it thin enough to move off the brush, but not runny. Load a long-haired sable rigger with this mixture. Brace your hand on your easel as you write. If you are not pleased, wipe the signature off and do it again.

If you need to sign a painting while it is still very wet, try writing with a ballpoint pen or other pointed instrument. It will pull the paint off, leaving your name etched in the paint.

FRAMING AND CRATING

The frame is the final cohesive influence that corrals the activity within a painting, unifying the many aesthetic considerations on the canvas. It also helps the painting isolate itself from the visual competition around it on the wall and in the room. Top-quality frames will enhance your paintings and pay you back.

Your hard work, beautifully framed, should be well packed for safe delivery to its new owner. A heavy corrugated cardboard box with a foam lining cushions your painting. Handmade plywood crates are an alternative to commercially made shipping crates.

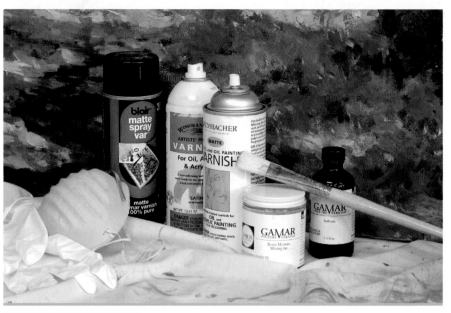

DIFFERENT VARNISHES

Varnish is a final protective coat for your thoroughly dried painting. Areas thinned with solvent or heavy with oil will dry unevenly because of the different oil content of the paint. The varnish will even out the surface.

PIGGY GOES TO MARKET

For shipping paintings, I use Strongbox™ shipping crates, made by Airfloat Systems. The foam insert in the crate has perforations so that you can create a "window" that fits your frame snugly.

Everyone experiences some form of "artist's block" at times. How do we stay fresh and nonformulaic? Is there another medium you would like to explore but have not? Does your daily routine need to change? Here are some "stretches" designed to help you answer those challenges.

MORNING MINI

Some days I feel like painting, other days perhaps not at all. One exercise that never fails to get me in the mood is to quickly grab a reference photo and paint from it on a 6"× 8" (15cm × 20cm) panel. Any photo will do—don't dull your senses by going through masses of reference photos. Give yourself five minutes maximum to find a photo.

Once you've found your photo, turn your reference sideways, upside down or right side up. Just start mixing paint and matching some shapes and colors. Soon you will be involved. Sometimes just swirling paint around stirs the creative side, like a hypnotic cue. Soon you will be invested, and time will quickly pass.

This exercise may spur you to a different image to explore, or perhaps to scan your unfinished canvases and realize what needs adjustment.

CHILD'S PLAY

Organize a day in your studio to paint and encourage a few children perhaps five to eight years old. Their parents will be thrilled that you are being so kind to their youngsters, but in fact you are enlisting them to give you art lessons. Watch their freedom and joy as they respond to shapes and color with intense focus and intuitive direction. This is the true process.

From this, you will take away a better sense of what it means to attack your work without fear, without the baggage based on outside influences such as public praise or gallery demands. Of course, academics must play a role in the artmaking process, but if you can nurture the innocent, playful spirit that children exhibit, balanced with deep emotional and intellectual skills, perhaps you will touch on some fantastic art.

SHAKE WELL

To get to the next level in your art, you may need to shake things up. If you continue doing what you have always done, of course you will get the results you have always gotten. Perhaps it is time for some research and development:

CHANGE YOUR PALETTE. Lay out all your favorite tube colors. Now put them aside and use a totally different palette of colors.

CHANGE YOUR MEDIUM. Work in watercolor, pastel or clay.

MAKE AN ABSTRACT BEGINNING. Instead of organizing your painting from the start, cover your canvas with colors, textures, values and scribbling, and work your way out of chaos to an orchestrated image.

MAKE AN ABSTRACT CONCLUSION. Start literally, but let go of the picture; let your shapes become abstracted and nonrepresentational. React to the canvas. Look for contrasts of warm and cool, light and dark, active shapes and quiet areas, opaque and transparent, thick and thin, hard and soft edges.

DOWN-TO-EARTH PALETTE

Sometimes I use a 16" × 20" (41cm × 51cm) canvas panel as my palette. This canvas was my palette for the painting demonstration on page 108, which uses an earth primary palette of Yellow Ochre, Burnt Sienna, Chromatic Black and Titanium White.

Look at the beautifully harmonious and colorful notes you can mix with a palette of earth tones. I save palette canvases like this one and use them as toned grounds for future paintings. Eventually this canvas will call to me as the perfect toned ground for some particular subject.

TRY A PALETTE CHALLENGE

GRAB BAG PALETTE. Literally throw twenty or thirty tubes of color in a bag. Stir, then blindly pull out three to five colors. Challenge yourself to create relationships with these unexpected choices plus white. Stick with your first picks, no matter what they are—going with the best selection out of three tries is cheating.

DOWN-TO-EARTH PALETTE. Paint a picture with Yellow Ochre, Burnt Sienna, Chromatic Black and Titanium White. Although these colors are not intense, they represent the primaries, yellow, red and blue. Dig in.

PAINT FROM MEMORY

Look at a reference photo for twenty seconds, then put it away. Paint your first impression of the picture. Do not overanalyze; trust yourself. Drawing from memory, ask yourself what color dominates and what value scale best represents your impression. Paint the entire painting without ever looking back at the reference.

This challenge will push you to focus on the big picture because you will have only a general impression in mind to work from. Normally, the longer you work on a scene, the easier it is to get lost in the finishing details and lose sight of the idea behind the painting and its overall quality.

A FEW PARLOR TRICKS

SHADOW BLOCKING. Cast some shadows of various objects on a wall: a head, a body, a vase, a toy horse. See how the simple silhouette—not color, texture or brushwork—explains the objects.

CAST THE SHADOW OF A BOUQUET OF FLOWERS. Look at this shape and see how interestingly nature can design shapes and negative spaces.

FIND A ROCK THAT RESEMBLES A MAJESTIC PEAK. Set it up and experiment by illuminating it from different directions and with different colors of light. In this

A MULTICOLORED TONED CANVAS
A toned canvas can be any color, any value or multicolored, such as in this example. Experiment with many choices and you may find some surprisingly good results.

way you are simulating the many times of day and shapes nature may create.

PAINT ON A TONED CANVAS

Generally, I work on white canvas. However, sometimes I enjoy painting on a toned canvas. A toned ground can add vitality and sparkle to the final work and also helps harmonize the final painting. Theoretically, any hue, value or intensity can work for a ground tone. Earth colors and warm or cool neutral grays are good for unifying the finished painting. You might also choose a toning color that is either analogous or complementary to the proposed color scheme of the painting. The choice is yours; experiment.

A concentrated session of painting can be both physically and mentally draining. If you realize that you are too tired and are no longer making thoughtful decisions, stop painting for now.

Bring the Outdoors In With Studies

Nature sparks my art spirit. As I paint a new subject outdoors, I attack the canvas in a rush of emotion. Later, in the studio, I fight to maintain that powerful intuitive reaction.

Materials

Palette
Cadmium Yellow Light • Cadmium Red Light • Ultramarine Blue • Titanium White • Portland Grey Dark • Portland Grey Medium • Chromatic Black

Brushes
No. 10 bristle bright • nos. 6, 7 and 8 bristle filberts

Canvas
20" × 24" (51cm × 61cm)

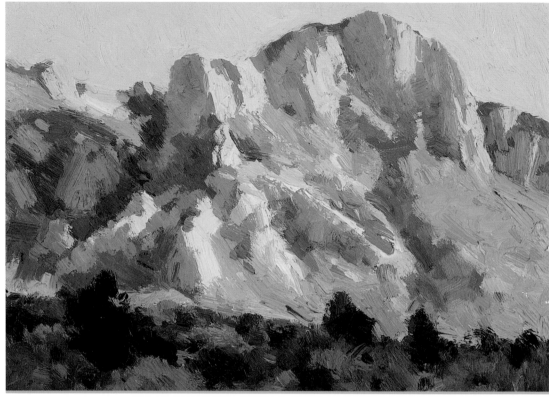

Monumental Light—Study 1
9" × 12" (23cm × 30cm)

STUDY 1: THE LIGHT

At Big Bend National Park in southern Texas, the light raked quickly. I really liked the color combinations nature offered this day. An anxious feeling overcame my body as I raced to get this study down, partly due to a few bears that were in the vicinity. It was a bit hard to concentrate.

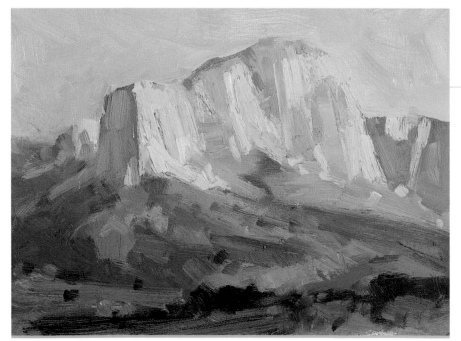

STUDY 2: THE SHAPES

In my next study, I simplified the scene into even fewer shapes. This study worked out most of the visual problems.

Monumental Light—Study 2
9" × 12" (23cm × 30cm)

1 Lay In the Plan

Put a few dabs of Cadmium Yellow Light, a pinch of Cadmium Red Light and a drip of mineral spirits right on your canvas. Wipe this all over the canvas with a rag to create a warm cast.

Use Portland Grey Medium tinted with a little Cadmium Red Light to quickly block in the shadows. (The yellow undertone will also get stirred in as you paint, further altering the gray.) Be conscious of the light shapes that are being created negatively, and try to connect them. Introduce some tints of other colors into the gray for the foreground shapes.

You may notice that I wiped off some paint and reshaped the light areas.

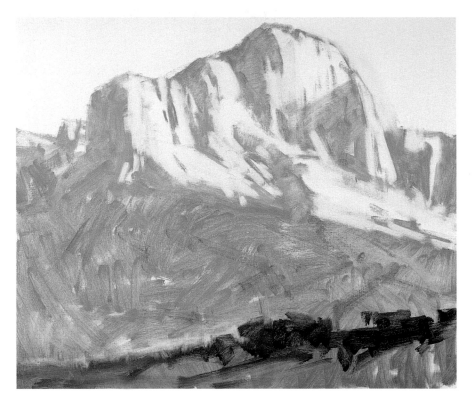

2 Add the Shadows

Use Portland Grey Dark to establish the next range of shadow values. Warm the gray with a bit of Cadmium Red Light for the distant cliffs. Mix some Chromatic Black into the gray for a few accents. The Portland Gray medium you applied in step 1 appears more luminous in the cliffs. It looks lighter because of the contrast with the dark cliff at the right. In a sense, you have lightened one area by making an adjacent area darker.

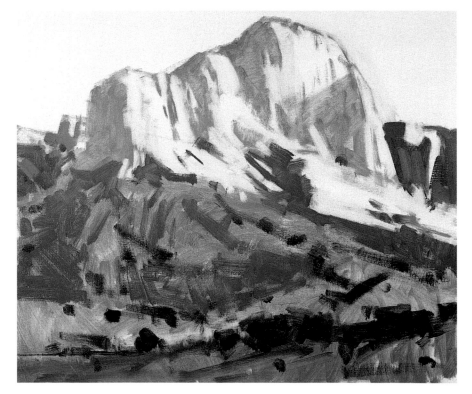

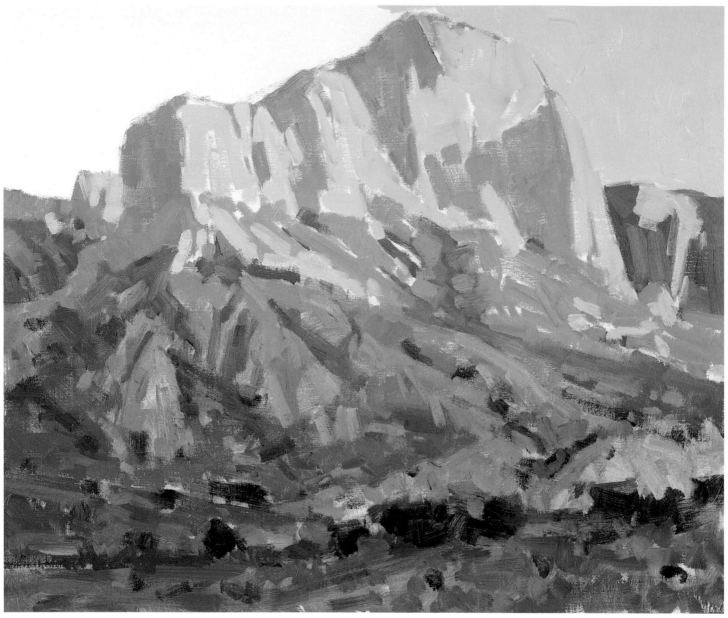

3 Fill In the Colors

Using a no. 10 bristle bright, boldly and simply fill in shapes with color. Follow the parameters of light and shade already established. I used warm mixtures on the light sides of the cliffs and cooler ones on the shadow sides.

Fill in the sky, working from right to left. It can be darker in value than you might think it should be. This will afford room for the cliffs to be sunlit and colorful. Make the sky warmer to the right (the sun side), cooler toward the left.

Move all around the canvas without making any area more finished than any other. This degree of finish could be left as is for a simple, bold statement, but we'll forge ahead, for better or worse.

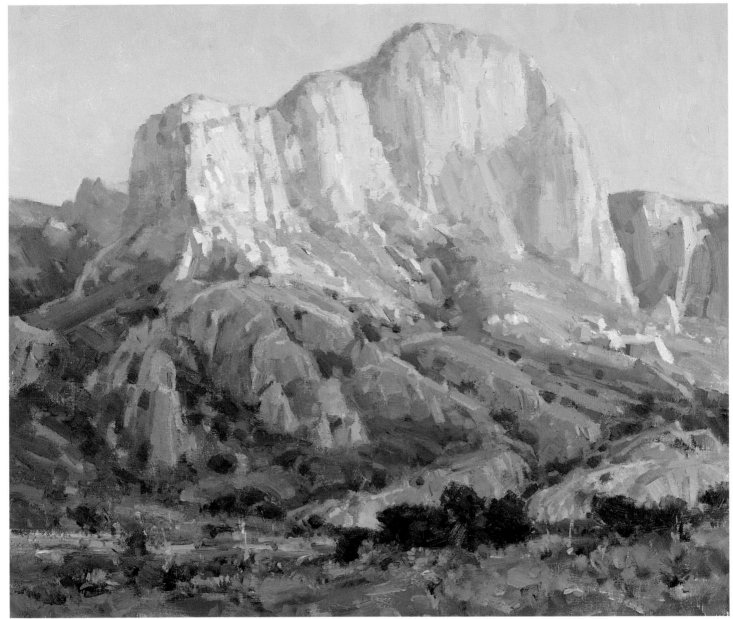

Monumental Light
20" × 24" (51cm × 61cm)

4 Finish

Play in the light and shadow, using the no. 10 bright and nos. 6 to 8 filberts. A no. 6 filbert is plenty small even for the narrowest shapes. Manipulate the brush on its side and adjust shapes negatively.

Find variation in the shadowed foreground. Search for colors that will enhance the effect of form and volume in the foothills. Cooler sky light illuminates the top planes of the rocky formations, whereas warm light reflects back into the upright planes. Make sure that the val-hues you choose for the shadow areas live within the shadow family, and do likewise for the light family.

Use broken color (see page 31) in the sky to add vitality to this relatively flat shape. A photograph cannot exhibit the vibrations of color you see when viewing life firsthand.

Contrast attracts the eye, so diminish the contrast in the shadow areas of the upper cliffs. This in turn creates more atmospheric light in the scene. Be careful not to destroy the light and shadow patterns when lightening areas.

Try an Earth Primary Palette

By now you may be getting comfortable with a limited palette. Don't get too comfortable. You can learn even more about color by further restricting the intensities of your palette.

Materials

Palette
Yellow Ochre • Burnt Sienna • Titanium White • Chromatic Black
Brushes
Nos. 6 and 8 bristle filberts
Canvas
16" × 20" (41cm × 51cm)

REFERENCE PHOTO
From this good photo, I painted a 6" × 8" (15cm × 20cm) color study in the studio. The study, seen in the illustration below, is where I solved the visual problems for this scene. I then put the photo aside and painted my larger work exclusively from the study.

THE EARTH PRIMARY PALETTE
Start by familiarizing yourself with this palette. Mix your rainbow: the best orange, purple and green, and many colors in between. Proceed to tint each puddle progressively with white. This colorful but muted rainbow is the range you must work with for this painting.

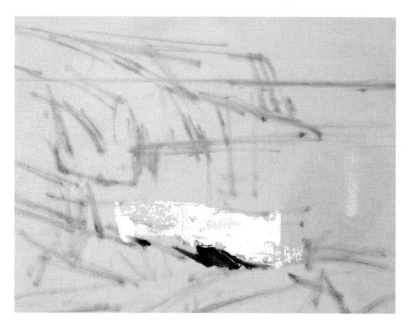

DRAWING THE HORIZON
Use a T-square to get the horizon level and straight.

1 An Extreme Start
Tone your canvas with Yellow Ochre and Burnt Sienna by putting a few dabs of each color on the canvas and rubbing them in with a rag. Draw the composition with a no. 8 filbert.

For the extreme value notes, mix a rich dark black out of Chromatic Black plus a pinch of Burnt Sienna, and a white from Titanium White plus a pinch of Yellow Ochre. Apply the darkest dark with a brush. Then load up your knife with the light mixture and boldly apply a stroke for the lightest light. The contrast of the lightest light and the darkest dark adjacent to each other will direct attention to this focal point. Compare all other color notes to these.

2 Add Color

With a no. 8 bristle filbert, place the shadow shapes as flat areas of color. (Too much texture in shadow areas can appear to lighten them, so let the light family areas have most of the texture.)

Using a palette knife, place the extremes of each color family—red, green, blue, purple, and so on—within the light family areas. (Using the knife for the light family adds welcome texture.) You don't have to commit to these color cues yet.

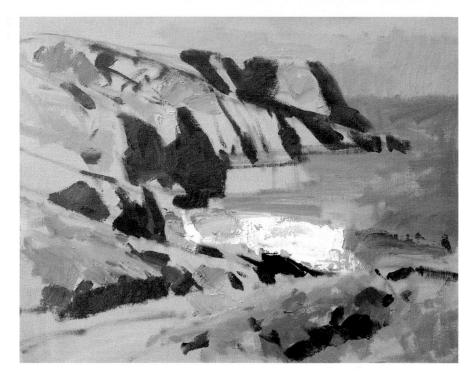

3 Cover the Canvas

Continue adding color. Once you get the toned canvas entirely covered, it is easier to evaluate the color notes. Evaluate and adjust as needed. Remember that there are two ways to adjust any relationship. If one shape looks too warm or too dark, some other shape may in fact need to be made warmer or darker. Continue using both the knife and the brush in different areas for textural contrast. Don't be afraid to scrape areas down to bare canvas and re-work them if you deem it necessary.

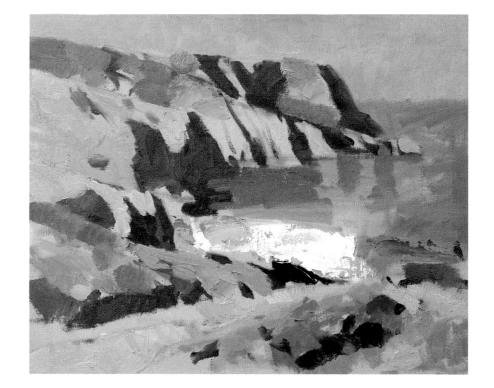

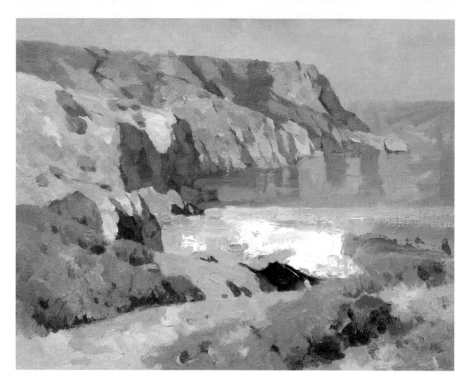

4 Work Both Families

Add val-hues in both the light family and the shadow family. Continually remind yourself which family you are working within so that you will get the value ranges right. Remember the black and white cow example on page 35.

As you work, your color shapes—the pieces of your two-dimensional mosaic—should get smaller, creating a more refined and realistic image.

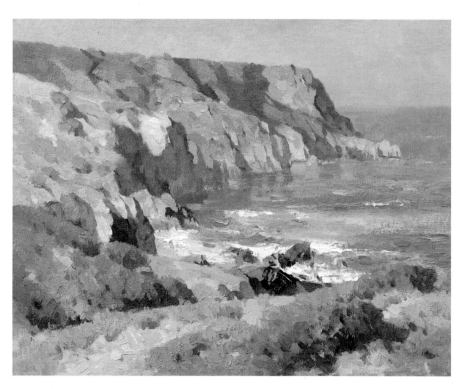

5 Build the Colors

Continue adding and refining, keeping the val-hues correctly related. The longer you work in this restricted range of color, the more complete this color environment will appear.

This painting will tax your mind to relate all your colors. But, believe me, it would be no different if you had fifty brilliant colors to choose from. No matter what your palette, every color, value, shape and edge must relate correctly to all the rest.

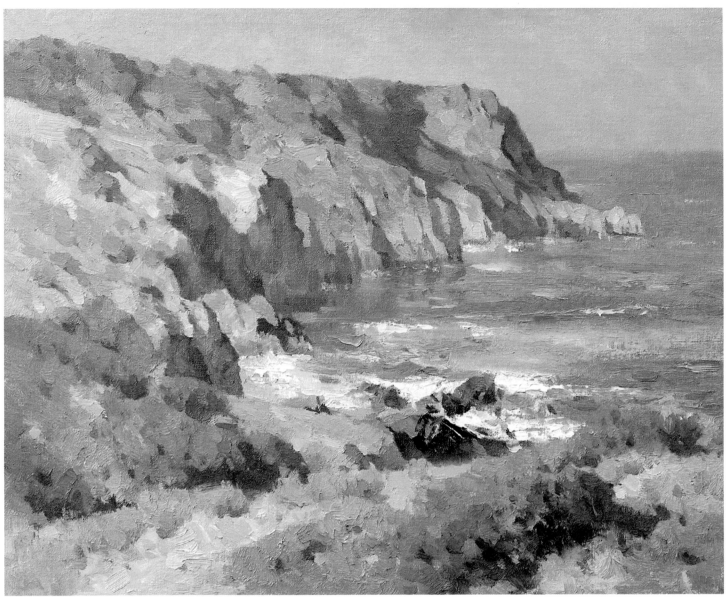

6 Finish

Adjust the shapes until you consider the painting done. Visually travel through my finished painting above, comparing it to step 5 and searching for the small or delicate adjustments I made.

Shark Harbor
16" × 20" (41cm × 51cm)

The start divides the picture into the most important and contrasting shapes. The finish refines, modulates and varies these shapes without destroying them.

Communicate With Strong Color

I chose to use strong colors for this painting: complementary oranges and blues, both warm and cool. The distinct values and colors suggest the clean, crisp, dry air of autumn. The color choices also help create the illusion of space. Cool blue shadows in the distant mountains recede in comparison to the warm colors in the foreground.

Materials

Palette
Cadmium Yellow Light • Cadmium Red Light • Alizarin Crimson • Ultramarine Blue • Phthalo Green • Titanium White

Brushes
Nos. 6, 8 and 10 bristle brights • nos. 6, 8 and 10 filberts • no. 10 badger hair

Canvas
30" × 40" (76cm × 102cm)

STUDY
This 6" × 8" (15cm × 20cm) study was my guide for the block-in of the larger canvas.

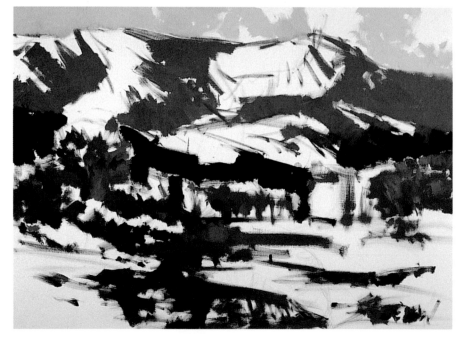

1 The Start
Start big and bold. The color doesn't have to be perfectly accurate. Just do a quick first application to get yourself moving.

2 Cover the Canvas

Fill in the light sides of objects, working with the same mindset as you did in step 1—just get the paint down. A lot of this may change, but by getting the canvas covered quickly, you have the wholeness of the painting to work with.

Get the sky pretty thoroughly complete at this early stage. Areas with close values, such as a sky, are difficult to go back into later because the very subtle value changes are hard to match if you work wet-on-dry.

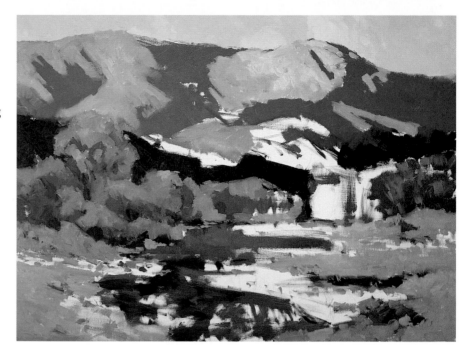

3 Refine the Middle Ground and Foreground

Start refining the middle ground and foreground with smaller color notes. Include some bold oranges and reds. When I spark up a painting with intense color notes, I find that it sparks up my enthusiasm as well.

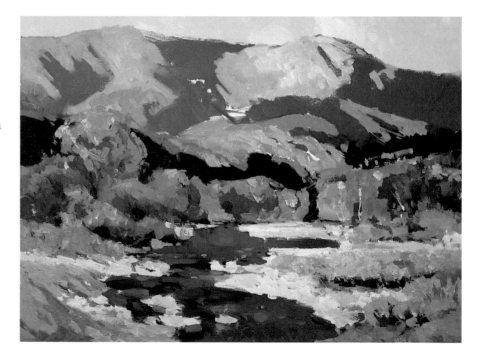

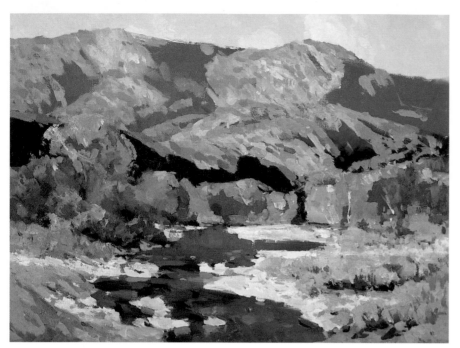

4 Refine the Sunlit Parts of the Mountain

Work over the light areas on the mountain and foothills, imagining tree masses, meadows and rock formations that create patterns and values to move and delight the eye. Add shadow shapes to the foreground grasses and shrubs to give them form. Paint, scrape and paint again until it feels right.

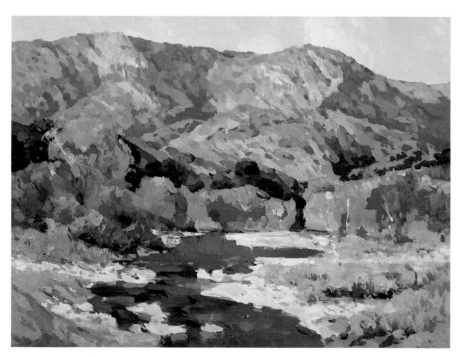

5 Add Subtle Temperature Changes to the Shadow Areas of the Mountain

Add the effects of atmosphere to the shadows of the mountain by slightly lightening the overall value with delicate temperature changes. Do the same with the darks in the middle ground. You're adding more information to these areas, but without destroying their place in the overall value plan.

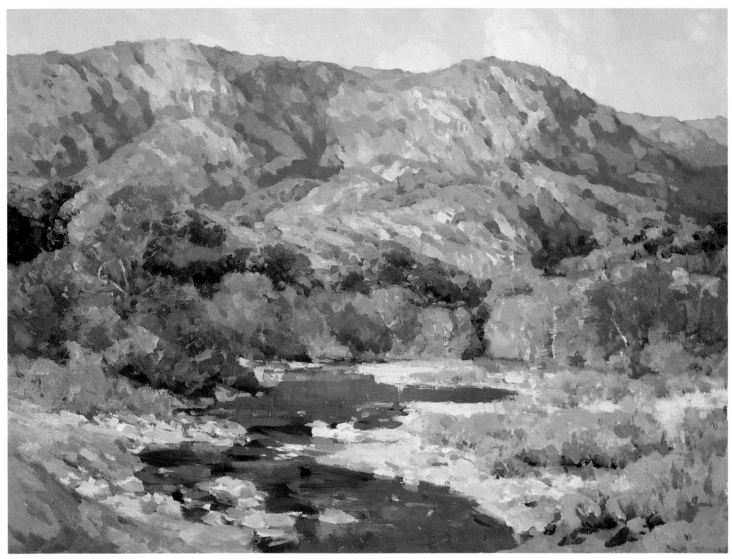

Gold Country
30" × 40" (76cm × 102cm)

6 Finish

Tickle shapes and edges to direct the eye through the canvas. For example, I changed the large amber tree on the left and eliminated the very harsh edge on the green tree next to it because the harsh contrast attracted too much attention. Study this finished painting carefully to see all the many subtle changes from the previous step.

Our eyes are windows to the world and to the soul. Look with emotion.

See and Paint Even Difficult Subjects

Materials

Palette
Cadmium Yellow Light • Alizarin
Crimson • Ultramarine Blue •
Titanium White

Brushes
Nos. 6, 8 and 10 bristle filberts

Canvas
20" × 24" (51cm × 61cm)

Many artists fear painting water, but it really is no more difficult than any other subject. The keys to seeing and painting explained on page 50 apply to any subject. Analyze and compare everything in relation to the extremes. If you get the color spots right, the water will create itself. Use the edges of the water shapes to convey whether the water is calm, moving or turbulent.

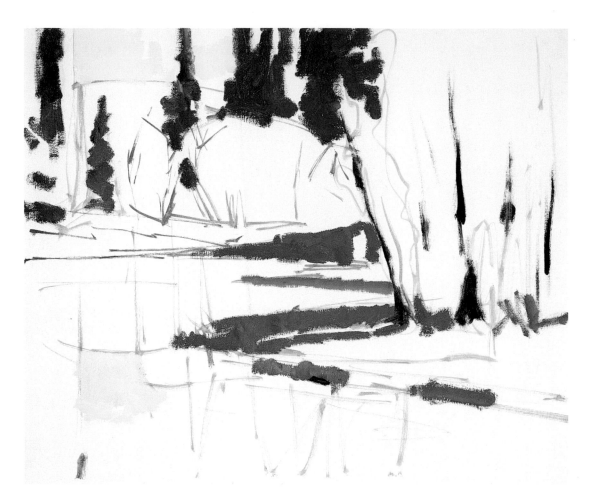

1 Map Out the Elements
Draw the composition using Cadmium Yellow Light and Alizarin Crimson. Place the lightest lights (the cloud and its reflection in the water), making the cloud's reflection in the water slightly darker in value than the cloud itself. Place your darkest dark in the shadow areas. Because you are establishing all of the shadows now, you will have an easier time maintaining the direction of the light. Use the colors you see in the shadows.

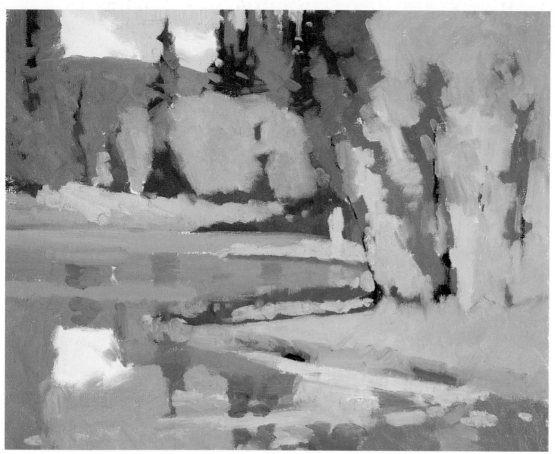

2 Block In

Block in all the light areas with flat areas of color. Focus on the larger masses.

DETAIL

I painted these trees from back to front, though I don't see that as a hard-and-fast rule. I did, however, add the sky color last. As long as you remain conscious of all the comparable relationships, there is no one right way to attack your canvas. You will find a method that works for you.

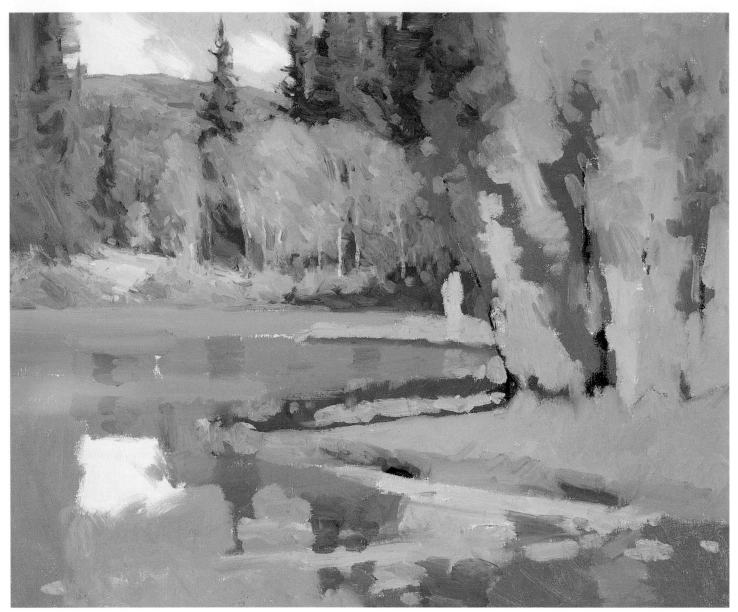

3 Refine the Shapes

Start adding color variations to the larger shapes. Pay close attention to the edges of these shapes; redesign them if necessary. Be careful not to destroy the pattern of light and shadow that you established in step 1.

4 Finish

Add smaller detail shapes within the larger masses. Notice that I made a compositional correction here: I realized that the trees on the left denied both entrance to and exit from the painting, so I lowered them.

Blue and Gold
20" × 24" (51cm × 61cm)

A painting of nature is neither nature nor the painter, but rather the communion of both—a new and separate being.

Use a Set Palette

This large studio painting was done with a set palette inspired by the color notes in a small study. I premixed all of the major color notes before starting the large canvas.

Materials

Palette
Cadmium Yellow Light • Cadmium Red Light • Alizarin Crimson • Ultramarine Blue • Titanium White • Portland Grey Light • Portland Grey Medium • Portland Grey Deep • Chromatic Black

Brushes
No. 10 bristle filbert

Canvas
30" × 40" (76cm × 102cm)

1 Start in Neutral Gear

Using old rags and wearing gloves, tone your canvas with Portland Grey Light. This tone kills the whites. From here on, think of this light gray as your white, the lightest value available to you.

Begin to sketch the scene with a no. 10 bristle filbert and Portland Grey Medium that has been thinned with a bit of medium and spirits. Describe the shapes further with Portland Grey Deep. As you begin to use the Portland Grey Deep, it will mix into the Portland Grey Medium and create some tonal variations. Add some black to the Portland Grey Deep to create another, darker step in the tonal range. You still have room to use black by itself for your darkest tone if you decide you need to.

Connect and unify the darks. Use light and dark contrasts to help describe the forms.

2 Decide on a Color Scheme

When you are satisfied with the value plan from step 1, turn to a study for input on color choices. Pre-mix large puddles of all the major notes of color from your study, carefully matching the colors and the value range. Use a palette knife to mix, and wipe the blade after each mixture to keep the puddles clean. This is now your set palette for the new painting.

My study yielded the following set palette: Cadmium Yellow Light; Cadmium Red Light; a purple made from equal parts Alizarin Crimson and Ultramarine Blue; Phthalo Green; and Titanium White. (I excluded pure blue from the set palette even though I will seek blue relationships in the painting.)

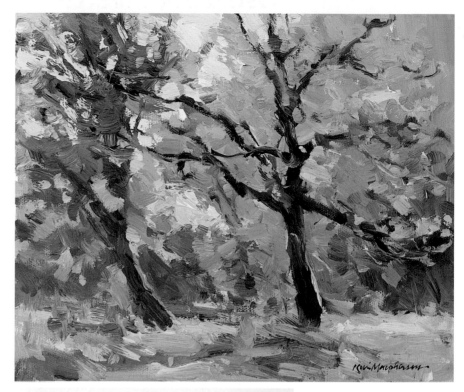

3 Introduce the Set Palette to the Painting

Start adding the premixed colors to the painting. For now, use the mixtures as is, without further intermixing. This establishes the color harmony.

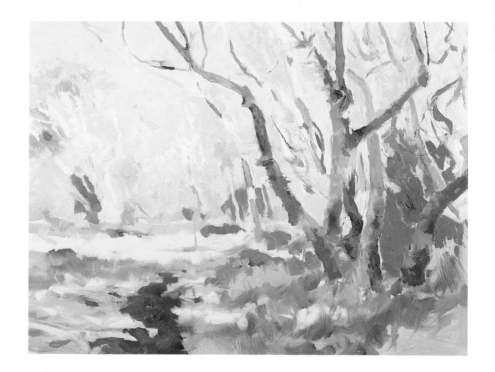

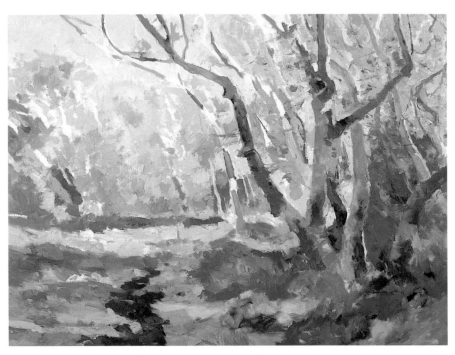

4 Mix It Up
Keep building the painting with the premixed colors. After the canvas is fully covered, you can start creating new mixtures and let the painting direct the finish. As you add colors, any mixture not related to the set palette harmony will scream out to you.

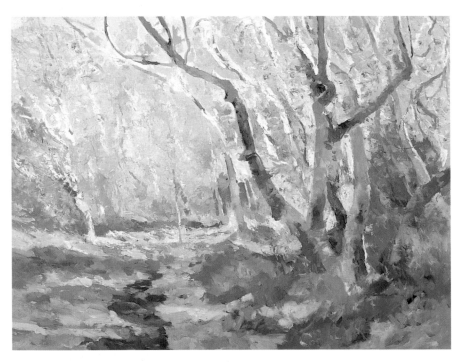

5 Refine With Smaller Shapes
Refine and define the forms with smaller shapes of color, being careful to maintain the established value plan.

Interpret nature with the varnish of your life experiences. Embellish nature with your own ideas.

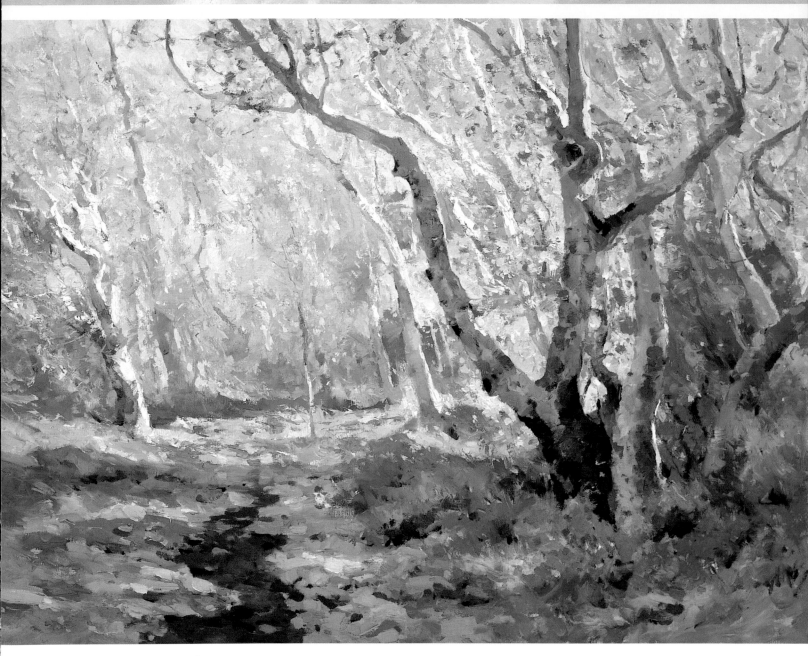

6 Add Finishing Touches

Complete the statement without overworking. This step is not necessarily a big one, but it may take some time. Each finishing strokes requires a lot of thinking before the brush touches the canvas.

Spring Greens
30" × 40" (76cm × 102cm)

THE FINISHED PALETTE
This canvas was my palette for *Spring Greens*. The wonderful colorful mixtures and the scraped, textured surface will make a unique and challenging base for a future painting I might call *Painting Out of Chaos*.

7

THE PATH TO SUCCESS

Your art quest begins well before you start to put paint to canvas. It begins with these questions:

Why do you paint?
What does success mean to you?

As you struggle to find the answers, you start the artful process. Once you know how to express it to yourself, you can begin to share that expression with others on canvas.

Why am I asking you these questions? Because a good teacher should motivate you to become a self-learner. If you are able to continually learn and challenge yourself, you will be better equipped to take charge of your own success.

finding motivation

Why Do You Paint?

If you can answer that question honestly, the rest will come in due time.

Here are some of the many reasons students say they paint.

WHY I PAINT

For me, painting is a spiritual, emotional and meditative connection with Mother Nature. Just mixing paint, seeing the interaction of color combinations, is pleasurable. I have always felt an inherent need to express myself in pictures and colors—maybe because of shyness, or maybe because of some bit of praise I received along the way. Being myopic (nearsighted) increased my sensitivity to color and soft shapes. Art is the only thing I ever entertained to do.

"I paint to record my feelings about the places I've been and the world as I want it to be."

"I want to capture on canvas with paint what I visualize in my mind."

"I bleed pigment."

"My dream was to attend art school, but I was urged to go for a more practical degree in . . ."

"It is something I have to do, like breathing."

"Painting feels more natural than talking."

"An illness or divorce made me realize how much I regretted neglecting my art."

"I have a passion for the outdoors."

"Painting is always challenging and rewarding."

"It gives me identity."

"I want to record nature before it disappears."

"Life is short; I want to spend time doing something I enjoy."

Note that not one of these respondents said, "I want to achieve fame and fortune." You might achieve notoriety and significant income from painting, but if that is your only reason for painting, you will miss the bigger payoff: the enrichment of your artistic soul.

Justin Vineyard
16" × 20" (41cm × 51cm)

Why Don't You Paint?

"I'm too busy [growing up, making money, raising a family] to practice art."

Life in general can get in the way of creative zones, but you must make the time and place to create.

"It's too hard [physically or intellectually]."

Art is difficult, but that is so for everyone who tries it. I have heard many students—including people who have achieved the highest standards in many other arenas—say that art is one of the hardest things they have ever done.

"I'm afraid of failing."

Abandon your fear. It is not illegal to do a bad painting.

"I don't have anyone to encourage me."

Surround yourself with inspiring people. You can find support and encouragement among like-minded people in art workshops. But you can be inspired by people in all walks of life, not just artist types. You could learn much from your gardener's love of color and nature, or from a businessman's passion and entrepreneurial spirit. You can also learn to motivate yourself.

"I'm afraid I won't 'fit in' as an artist."

Artists come in all shapes and sizes: tall, short, heavy, thin, old, young, disabled, male and female. Our strength comes from within; we all have an opportunity to shine.

"I'm too old to start now."

Everyone is young at art. The benefits of starting art late in life are many.

- You've settled in to accept yourself and feel comfortable with your own voice.
- You have life experiences that will inform your art. You truly have much to offer.

A Pause in Brussels
14" × 11" (36cm × 28cm)

- Coming to art late in life may strengthen your resolve to work at it. Chances are something strong within you has been drawing you here all your life.
- If you're retired, you may have more time now than ever before to pursue art. If you do not need to make money from art, you can work for enjoyment instead of a paycheck. It will renew your sense of self-esteem.

In short, don't let age discourage you. However many years you have left, living artistically is making the most of life.

Painting outdoors is the best vehicle I can think of for feeding one's artistic spirit. Unfold your easel, capture the experience and share the joy with others. Each time opportunity knocks with a chance for exposure, open the door. Remain a student all your life. Above all, keep painting.

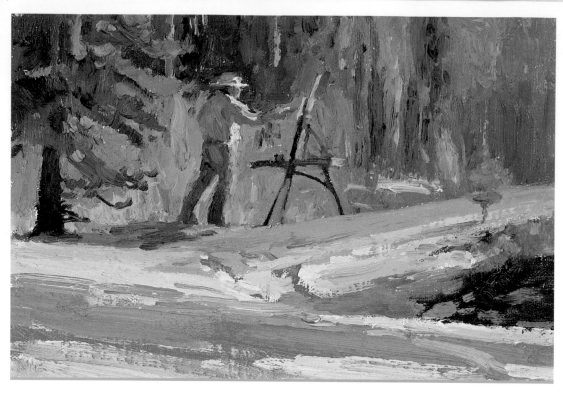

En Plein Air
6" × 8" (15cm × 20cm)

DEFINE SUCCESS

To succeed in art, you must first determine what success and art truly mean to you. If your goal is to reach financial success as an artist or to win awards, what will drive you to continue with art once those goals are reached? If you have an insatiable appetite to create, you will not stop, and the rewards will come.

CREATE AN INSPIRING ENVIRONMENT

Create an environment for painting that nurtures inspiration. You may want to work close to home in comfortable surroundings that release intimidation for creative thought, or you may need a foreign environment to stimulate curiosity. Visiting museums is another way to be inspired.

Don't forget about the environment you create within yourself. Too much ego can be detrimental to success if one is unpleasant to be around or unable to accept criticism. But an artist needs a healthy ego. You must believe in yourself enough to stand up for your artistic expression and offer your art to the public.

SET A COURSE

To achieve your idea of success, you need to learn the visual vocabulary necessary to communicate your ideas. Do you need further study to do this? Let the requirements of what you want to communicate direct your learning process. Perhaps you need to study with a master colorist, become a better draftsman or practice drawing from live models. Seek out relevant books, classes or workshops.

You also need to set goals for milestones you consider important. What are your dreams? Do you want to have a one-man show? Quit your job to paint full-time? Get in a gallery? Travel to paint? Make more money from your art? Write down your goals and make a plan to achieve them. Be realistic, but remember it costs no more to dream big.

Set goals on a time frame: one month, one year, three years, ten years. That may sound a long way off, but, believe me, it goes fast—especially if you are enjoying the learning process. And it does take a long time to learn the skills. Great achievements demand great determination, discipline, motivation and passion.

Keep a Progress File

Note the date on paintings and store them together as a record of your growth. Each time you master a challenge, it gets replaced by a new challenge, so it is often difficult to remember how much you have progressed. Revisiting your earlier work may boost your confidence.

Positive energy, positive people, positive attitude.

PAINT, PAINT, PAINT

The more you paint, the faster you will progress. Progress is evolution, searching, exploration of different ways to express yourself. Sometimes you touch on a new high or a new low, but always keep reaching for that elusive best.

Never stop learning and being curious. You might think that, once an artist "makes it," it is smooth sailing. On the contrary, you must always refresh your mind and body and seek ways to express and improve your craft. The best formula for a successful painting career is persistence. Harness your natural enthusiasm for what you do. Dedicate yourself to art.

Set goals in small increments on your way to a larger goal and re-evaluate them yearly. When you reach the peak of one mountain, it may turn out to be a foothill from whose top you can see another long-range goal in the distance. This journey enhances your artful life.

The "X Factors" for Success

EXPRESS. Declare your interest.

EXPERIMENT. Be more intuitive. Be free—go wild; the art police won't take you away. Step out of your comfort zone and paint a challenging subject.

EXPERIENCE. Each painting is a stepping stone to the next.

EXCEL. Seek the highest standards. Step to the easel with the intention that each painting will be your best yet. Focus—two or three minutes of focused activity is better than two or three hours of lackadaisical paint-pushing.

EXHALE. Refresh your mind from time to time by taking breaks. Have a sense of humor; laugh at your failures and smile at your successes.

EXCUSES. Take responsibility for your growth. When you stumble along the way, it is not your teacher's fault, the gallery's fault or the president's fault. Change your goals if necessary, but don't make excuses.

EXPECTATIONS. Be positive. Prepare for success. Accept and expect it. If you approach your painting without expectations, I am sure you will meet them. Push yourself and reach for greatness.

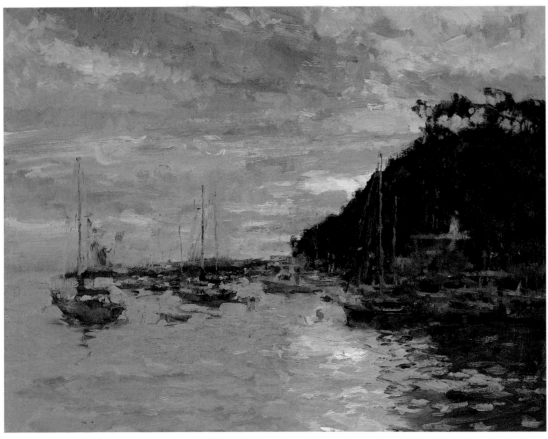

Here Comes the Sun
16" × 20" (41cm × 51cm)

Practice the academics so you can passionately attack the canvas correctly. The fundamentals must be deeply ingrained so your mind can wander into your emotions.

Participating in a painting workshop is not just for beginners, and it's not just for professional artists. Anyone can benefit from the experience. There are many reasons to try it:

IMMERSION. You will be able to immerse yourself in art without interruption, away from family responsibilities and distractions.

INSTRUCTION. The guidance of a respected teacher might bring out your best.

INSPIRATION. A class brings together artists of diverse styles and abilities where they can learn from each other. The beginner solidifies the basic skills needed for expression; a fine draftsman tackles complex subjects. One artist applies the paint boldly; another has a delicate touch. One works with subtle grays and another with intense color combinations. You'll observe a great many pictorial solutions, and that experience will give you more choices in your own work.

Being around other artists in a workshop setting will also teach you about the passion, dedication and hard work necessary to live and survive as an artist.

GETTING THE MOST FROM A WORKSHOP

Above all, be a blank canvas, ready to receive everything you see and hear. A workshop should fill you with ideas and stimulate your imagination for years to come. Each student picks and chooses the information most relevant to his or her own artistic direction. You may hear concepts that you don't use now, but which will suddenly become very relevant to you after you have a few more years of experience.

A workshop is not a time to show off or to produce a finished painting, although the process of exploration may lead to your best work yet.

If you disagree with a workshop teacher, ask the teacher to explain further. You may still disagree. That's okay. This is how you formulate your convictions.

Mary K.
16" × 20" (41cm × 51cm)

Leave Your Doubts Behind

If you've never painted outdoors before, doing it alone can be intimidating; joining a plein air workshop may get you hooked.

Don't be embarrassed about painting in front of others. Share your joy with your onlookers. Engage others in your search for wonderful color. The interaction in a workshop setting will build your confidence and your "outdoor painter's character."

Pace yourself realistically. Do not compare your work with that of someone who has painted for thirty years. Look up to the experienced painter, but do not expect to obtain that skill level in a short time.

Don't worry about having a style; let it develop naturally. Style is inherently personal. It is forged by the merging of your inner voice, your skill and your technique. What about the world excites you—what do you want to communicate with your art? How do you answer visual questions on canvas? One artist may use color, another moody values, still another fine draftsmanship. Style goes beyond technical ability. Sometimes it is not necessary to use all skills at their peak to communicate what you want to say. So focus on the academic skills and techniques most necessary to communicate your vision.

OUTSIDE INFLUENCES

The many fine examples of art in books, galleries and museums can be both inspiring and confusing. It would be foolish not to learn from great artists, but find a way to incorporate what you have learned into your own style. Your vision is just as valid as those of the masters.

Your style cannot help but be "personal" if you are true to yourself. It may take a long time to feel as though you have something to share, but each of us is unique. Express and believe in this uniqueness. *This is your voice.* You can paint like anybody—even yourself.

PLOT YOUR OWN COURSE

Others may not always share your vision. Blind ego is not productive, but it is important to develop the courage of your convictions. Teach others to see things your way. Eventually your voice will speak louder than others' opinions, even when you whisper.

Style vs. Content Exercise

Style is not an end in itself; the message is what matters. To convince yourself of this, all you need is a notepad, a pen and a photograph (such as the one on page 66).

1. Describe the scene in the photograph in twenty words or less in your own handwriting.

2. How does the scene make you feel? Quiet, agitated, awed, energized? Jot down a few words to describe your feelings.

3. Choose one of those feelings and express it in a paragraph of prose.

4. Reduce the words you wrote in step 3 to a poem, eliminating unnecessary words.

5. Ask yourself what gives your poem its power. If you had no profound thoughts at all about the scene but wrote your words with beautiful handwriting, your handwriting would not be able to make up for the lack of content. But if the words are well chosen, poetic and arranged to touch the soul, it doesn't matter if the handwriting is so-so. The thought will overpower the handwriting and will still manage to touch someone reading the poem. (Eloquent, well-chosen words in beautiful handwriting will touch even more of the reader's senses.)

6. Once you are finished, put the photograph away and paint the scene from your written notes only. How did you do?

God gave you the ability to paint like anyone you want—even yourself.

As artists we often deal with negativity. We critique or assess our work, which usually entails searching for the flaws so that we may better understand how to improve. Self-critique is important to do, but it can also be depressive. It is just as important to look for what you are doing right in your paintings so that you can continue that growth in a positive direction. So, as you try the following methods for evaluating your work, don't forget to notice the areas of beauty and expertise in your paintings as well as aspects that may need improvement.

THE OBJECTIVE TOOLBOX

So many facets contribute to the success of a painting that it is often easier to examine one principle at a time. Start by assessing your painting by the following objective criteria:

PATH. How does your eye move through the painting?

CENTER OF FOCUS. Do you find yourself settling in on the area you intended as the center of focus, or do other areas fight for your attention? Do contrasts need to be emphasized or reduced to remove distractions from the center of focus?

COMPOSITION. Does the painting hold together as a balanced arrangement of values, colors, shapes and movement, even when viewed upside down or in a mirror?

EDGES. Do the edges describe the physical qualities of the objects represented? Do they enhance the visual path through the painting?

UNITY. Is there a dominant idea, shape, color, value or direction of visual movement that expresses the idea behind your painting?

VARIETY. Is there ample contrast that adds vitality to the composition: variety of shapes, value, textures, colors, edges, directions?

DRAFTSMANSHIP. Does this painting exhibit accurate shapes and placement?

PROPORTIONS. Do they feel right?

COLOR AND VALUE. Are the choices reflective of the mood you wanted to convey? Do they create a believable representation of light and atmosphere?

LIGHT SOURCE. Does the painting have a dominant light source, and are its direction, color and intensity consistent throughout the painting?

THE SUBJECTIVE TOOLBOX

Remember, a well-executed painting without passion is only an exhibition of technique and craft—not art. Be sure to examine the mood, the emotion, the personal feeling your painting embodies. These are subjective criteria, but they are no less important than the objective toolbox.

IDEA. Does the painting communicate your vision, the idea that made you want to paint the subject?

THE HUMAN ELEMENT. Does the arrangement evoke the senses, move the spirit and reveal the soul of the individual that produced this picture?

EMOTION. How did you feel about the subject? The more you succeed in revealing emotions in a finely crafted statement, the nearer you come to excellence in art.

Realistically, less than half of your outdoor studies are likely to work well enough to become finished paintings. Save these "failed" pieces, because they still have worth as references for colors, values or the arrangement of shapes. One study can lead to many studio works. Even a thumbnail-sized patch of color could inspire you to create something else.

I must have hundreds of unfinished outdoor paintings. Some I felt were failures; others just were not up to the standards I expect of myself. I do not try to fix these canvases. I'd rather redo than overdo.

Each year, I cull out these "failed" canvases. First I look for areas within them containing colors that could work wonderfully as a set palette for a future painting. I literally cut out these strips for later reference. These color notes are valuable because they were taken from direct observation. I sow these colorful seeds and eventually reap future paintings.

And as for the rest of the failures? I make an offering to the art spirits in the wood-fired "offering oven" in my studio. It is very liberating.

Always move in a forward direction. If a painting is not working out, redo it or move to another idea. Don't feel that any painting is too precious.

"Do you paint, Wanda?" I have been asked that question for most of my and Kevin's married life. My mother was creative, but I was never drawn to art growing up. My degree was in business. I was exposed to the art world through Kevin and our artist friends. But, believing I couldn't draw so much as a stick figure, I didn't attempt drawing or painting for a long time.

About fifteen years ago, I decided to try to draw Kevin's portrait. It looked like a Christmas ornament—quite comical. Then, on a trip to Canada, I borrowed one of Kevin's many easels and tried painting outside. I tried to use simple, flat poster shapes of color, as I had heard Kevin tell his students over and over, but I gave up halfway through. "Forget this," I thought, "it's too hard and too cold."

But Kevin kept on encouraging me, I think because he got tired of me telling him what to paint. Eventually I was bitten by the painting bug. Being a novice, I had no bad habits. I just looked for spots of color. I wasn't thinking about brushwork, technique or style. I truly didn't know what value was. Using cheap boards and student-grade paint gave me the freedom to practice. I let my skills develop naturally, with no worries.

I tried oil painting first, but thought it was too messy. I muddled through a watercolor workshop, and even took some sculpture workshops for the

Reflections of Serenity
Wanda Macpherson
16" × 20" (41cm × 51cm)

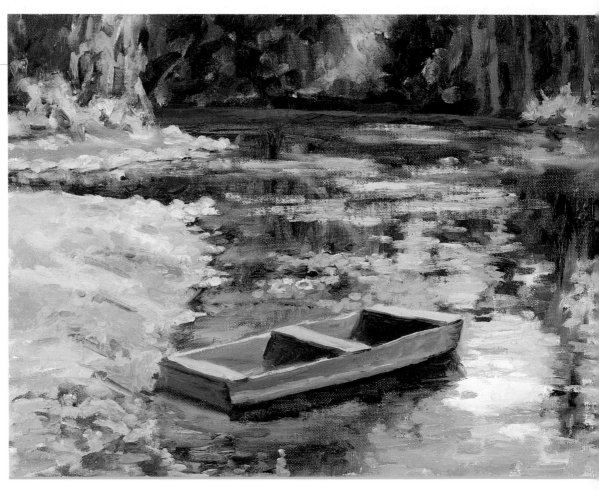

STACKS OF STUDIES, MILES OF CANVAS

opportunity to practice thinking three-dimensionally. I figured I would try different mediums and see if I liked one better than the rest. Painting seemed to fit our traveling lifestyle the best, and I liked the forgiving nature of oil paint, so I stuck with that.

Over the past ten years I have painted more than one thousand paintings, mostly oils and almost all of them painted outdoors. I truly believe that painting outdoors teaches the beginner to paint more realistically. Photographs do not show nature's true colors.

A few years ago I reached a plateau and was not making the progress I wanted. Delicate manipulation of shapes was difficult for me; I was a bit heavy-handed with the brush. Kevin encouraged me to paint architectural structures because they so clearly reveal form through patterns of light and shade. I challenged myself to work on difficult subjects, such as the human figure, as well as easier ones like sunsets. I kept plugging along, and a year or so ago I finally saw some changes for the better.

About six years ago I entered a show and won an award, and a gallery approached me to see if I was interested in being represented. I agreed, but I still don't push for publicity because I think pressure to sell would change my mindset. I enjoy painting just for the challenge of improving my skills.

Don't always go for the easy subject. Try to challenge yourself daily. I have braved the crowds to paint street scenes in cities from San Francisco to New York to Paris. I have tried difficult country scenes such as cows moving through a pasture. Most didn't turn out to be great paintings, but so what? At least I tried.

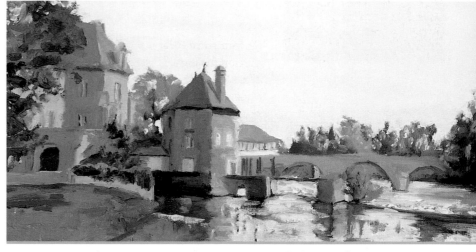

St. Savin Moulin
Wanda Macpherson
8" × 16" (20cm × 41cm)

It's not easy to put oneself out there and be criticized. Friends might ridicule your early attempts at painting (that happened to me), but don't let it get to you. Perhaps they are a bit jealous of your joy and wish that they, too, had a passion to pursue. It helps to have somebody by your side to paint with, but if you don't have active support within your family, a few art friends and some personal fortitude can carry you through.

I encourage anybody who is afraid to paint to at least give it a try. With any new endeavor there will be an awkward learning curve; do not fear it.

Thanks to my painting, I appreciate and see the world with new eyes. Art, something I never imagined attempting, is now something I can't imagine being without.

MAKING MONEY DOING WHAT YOU LOVE

If you want to make some or all of your money with art, tending to business will necessarily take time away from your creative efforts. Balance is the key. You need to tend to both the business and the creative sides of your work to make money from it in the long term.

There are numerous ways to increase your potential for earning some income from your art. It's important to try several different options. Even if a particular activity doesn't net you a great deal of financial reward by itself, it may help raise your profile, which then lets you charge more for paintings and for teaching.

WORK WITH A GALLERY. Establish a good relationship with a gallery. Ideally, you want a long-term arrangement with a gallery that loves your work and can sell it. It may take time to find the right gallery and to cultivate a good business relationship, but it is important because one must be in the public eye to gain recognition. Find a gallery near your home, one in which your work seems to fit and one you can keep an eye on. It is easier to work with a gallery within driving distance: You'll want to rotate your works and keep the gallery supplied with fresh art, and it is less expensive to do this if you don't have to pay the cost of shipping paintings.

HAVE A ONE-PERSON SHOW. When you are in the limelight, you must perform and exhibit your best. This added pressure and the associated deadline can increase your sense of purpose, your focus and your dedication.

ENTER COMPETITIONS. Submit to art competitions and invitational shows. Winners get free publicity, and many times galleries or magazines will notice. Competitions and invitational shows also introduce you and your work to other artists. The resulting exposure and contacts may lead to other opportunities.

TEACH. To teach, one must truly understand. Sharing your knowledge makes you contemplate your methods and reinforces your convictions. What makes a good teacher? Patience, humor and empa-

Roma
10½" × 13½" (27cm × 34cm)

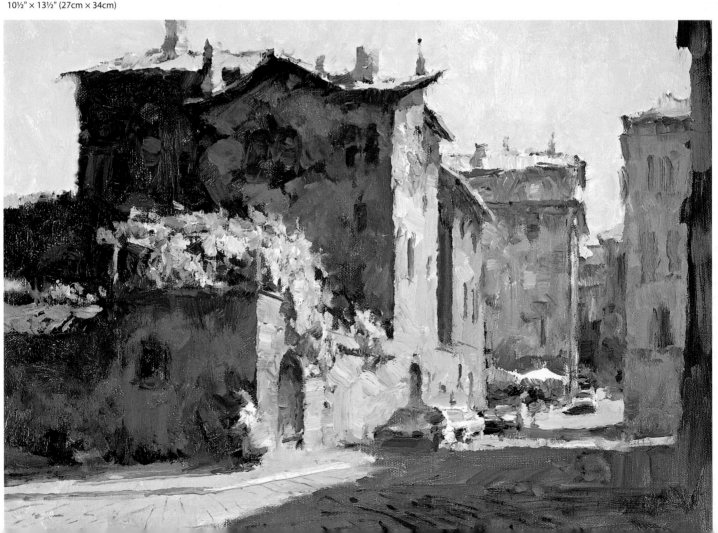

thy. A good art coach brings out the best in a student through encouragement, honesty and trust. Try teaching a friend to paint—it will help you, too.

Teaching exposes you and your work to many people. Advertising your classes gets your name out. A good teacher will develop a large following. You're also putting your art in front of a large audience that enjoys your work. Many students buy paintings.

WRITE. Like teaching, writing for publication helps you crystallize your thoughts. Having something published is also another way to get your name out. You'll make a few bucks while getting your name out, and being published as a writer will get you more respect than simply advertising.

ADVERTISING

Advertising is very costly. Be prepared to pay for multiple ads on a continual basis to get people's attention. I have advertised a lot over the years and, to be honest, rarely do I ever sell from an ad. Perhaps ads do enhance name recognition, however. Alternatives to advertising include direct mail to your collectors and entering shows that offer good exposure.

Web sites are another tool to exhibit, advertise and sell your work, but without prior public awareness of your name, a web site may not do much to attract attention. People can't find your site if they don't know you exist. Building recognition through shows, magazines, teaching and so on is more important. Have a business card handy with your website information. A website may show more examples of your art to someone who witnessed you painting on location, thus building your clientele.

COMMISSIONS

Commissioned work has pluses and minuses. It is an honor when someone wants to pay money up front in return for your artistic skill. And, of course, a commission is an opportunity to paint while getting paid. On the other hand, you are working for a client, and you may find yourself second-guessing your artistic decisions based on the needs of the client, not what may be best for the picture.

I accept the occasional commission that interests me. As long as you keep in mind the parameters inherent in this kind of work, you can decide for yourself whether to accept the challenge.

PRICING YOUR WORK

Pricing is a lot like fishing; at the right level you will get a lot of bites. It's a difficult decision. Obviously your time and expenses should be considered, but the most important factor is your reputation and the quality of your artwork. A painting from a renowned artist will fetch more than an equally good one of the same size by a lesser-known artist. But many buyers recognize there is value in paintings by up-and-coming artists who are exhibiting good quality at a relatively lower price. A high price can prevent some sales but can also attract a new, select group of buyers that appreciate good art and expect to pay a fair amount for it. A price that is too low can cause potential buyers not to respect the art.

The Connoisseur
6" × 8" (15cm × 20cm)

Art Groups and Competitions

Creating art is a largely solitary process, but it is healthy to be surrounded by others who share your passion. You can find support from other artists through art groups, guilds, and local and national organizations. Hurtful individuals exist in art groups just as in every other part of life, so do not be discouraged by those whose criticism isn't constructive.

Submitting to local, regional and national juried exhibitions is a chance to get feedback on your work. How do you know when you are ready to enter shows? You may never feel your work is good enough, for artists tend to be self-critical and always striving. So I would encourage you to just go ahead and give it a try.

A beginner's technical skills may not yet match his passion. Entering a competition and being rejected can be a jolt. If this happens, treat it as an opportunity to look more critically at your work.

Keep in mind, too, that a rejection may mean nothing. Jurors may be choosing from hundreds or thousands of entries. A juror's own personal preferences for certain subjects or techniques may interfere with his objectivity.

Find your own path. Let others follow you.

guiding principles for managing a career

Taking the Plunge: Painting Full-Time

- I loved my illustration career, but gradually I felt the pull to paint only for myself. I made a choice to give up the illustration and start over. My income dropped 95 percent the first year. My wife and I expected and planned for that, weighed the risks, examined the worst-case scenario and went for it. I knew I could always go back to illustration if necessary.

- Many artists wish they could be full-time artists but aren't sure how to make it happen. If your desire to paint is overwhelming, that's good: It needs to be if you are to succeed in a fine art career.

- Calculate the risks for yourself, then decide. Think about your minimum budget and what it would take to meet it. Painting smaller lets you complete works faster, and lower-priced works tend to sell more easily. So, if times get tough, fall back on painting small and selling inexpensively. If you get a job, you will not have time to paint, and there goes the dream.

- Many people wait years to decide, then wish they'd done it sooner. If you take the plunge into a fine art career, the water may be icy, but it is a very refreshing and invigorating lifestyle.

1. **FIND A BALANCE BETWEEN BUSINESS AND CREATIVITY.**
Some pressure might bring out your best work, but too much may shut you down entirely. Find an equilibrium that lets you move forward, striving for excellence while still enjoying the venture. If too many demands are made on your time, pick and choose what you want to do and learn to say no to the rest.

2. **DON'T LET DISAPPOINTMENTS BRING YOU DOWN.**
Every successful artist has had many rejections, more than any artist who has not made it, but negative moments never steer them away from their goal.

3. **BE PERSISTENT.**
Some artists think that when they get a feature article or a gallery exhibit, they'll have "succeeded," and art collectors and money will come knocking at their door. In reality, each success is just another step in the process of building credibility and notoriety. Your successes will snowball, but it may take a long time. The majority of very successful artists have been working hard at their craft for decades.

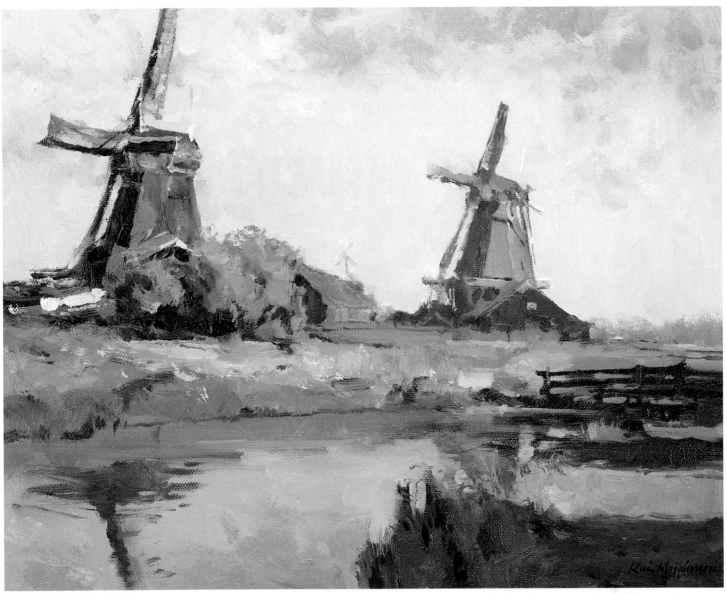

Zaans Molen
16" × 20" (41cm × 51cm)

4. FOLLOW YOUR OWN VOICE.

Don't chase market trends—doing so might bring short-term financial reward, but it will not pay the soul, and fickle market desires will soon change. It may be harder to sell subject matter that is very different from local tastes and knowledge, but sometimes foreign subject matter is very refreshing and stands out. Don't hesitate to paint any subject you want to paint. If you are attracted to certain subjects that aren't popular where you are, find a gallery that exhibits those subjects. Playing it safe is artistic death. Quality work will be rewarded.

5. KEEP GROWING.

Challenge yourself with new ideas, methods, techniques and subject matter. Do not repeat yourself; Continue to grow. We must remain enthusiastic and energetic.

Art enriches your life; feed your art and the art will give back. But also remember that artistic success is more than financial success: it means successful living, which each artist must judge for himself.

REFLECTIONS ON A POND

In August 1996, I conceived of a series of paintings. The term "series" is perhaps an inadequate description for what I eventually called my Pond Project.

This was not simply a group of works on a theme, nor a one-year exploration of a subject. Rather, I conceived the Pond Project as a physical challenge and a psychological adventure in which a view of a pond would be frozen on canvas, to be compared to others done at different times of day and in all seasons.

Initially the project had no definite end, even if it did have a method. My plan was to do one painting for each day of the year. Because of my teaching and exhibition obligations, which require travel, I knew the project would take several years to complete. But I was ready to make the commitment and

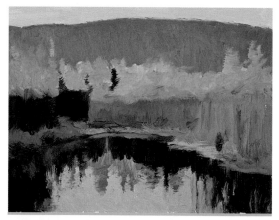

MAY 11

began marking a calendar with the days we would be gone and the days when we would be home to view Aspen Lake, a manmade pond approximately an acre in size.

The pond is only 100 yards (91m) from my home. My front deck and the bay window of the dining room directly face this microcosm of nature. Encircled by mountains, the ever-changing pond is surrounded by aspens, red willows, pines and spruce.

Although change was at the heart of the project, I held several elements constant. I did each painting on a 6" × 8" (15cm × 20cm) panel. I used a consistent palette: Alizarin Crimson, Ultramarine Blue, Cadmium Yellow Light and white. I stayed with one vantage point, looking out either from the window or from the front deck. I was also faithful to the reality of the scene's composition, recording the physical elements in their actual relationship to one another.

Other factors varied, however. I created each painting at a different time, dictated in part by whatever special lighting effect might catch my attention. All times of day appear in the series, including evening with a rising moon. Of course, I couldn't control the weather, which sometimes changed literally from minute to minute as I painted.

But this is not simply a series about seeing as an artist. There can be no translation of the visual experience without feeling. Intermixed within my pigments is my heart. Changes in the pond became a metaphor for changes in my personal life.

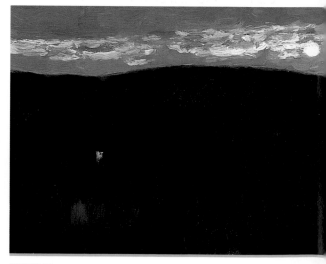

JULY 29

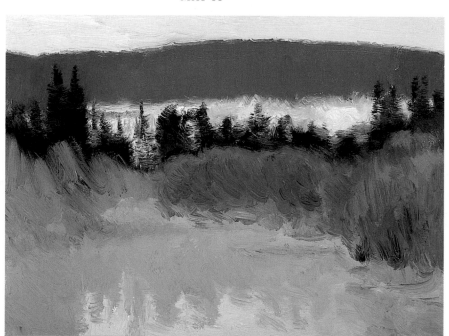

JULY 25

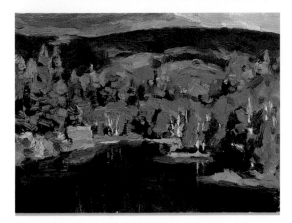

AUGUST 7

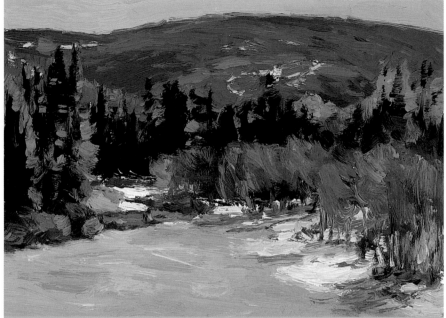

DECEMBER 4

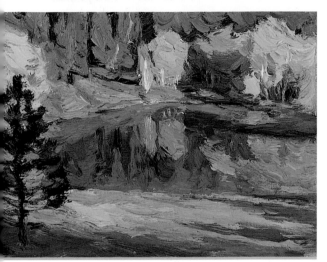

OCTOBER 5

Viewing the 368 painting makes a case for the axiom that there is nothing more constant than change . . . even if most of us fail to notice it. It's a heightened awareness we all seek.

It is interesting that so many artists think their home territory is uninspiring. As you get involved in outdoor painting and start to really see and sense nature's effects, any place will be inspiring, including your home territory. The land has not changed, but your artist's eyes have.

Painting small is not difficult to fit into your lifestyle. Painting a series generates a wealth of visual information. Committing yourself to a project gets you off your creative bum, much like an exercise program. Your project will help you get through times of artistic block. It takes miles—miles of canvas to reach artistic goals.

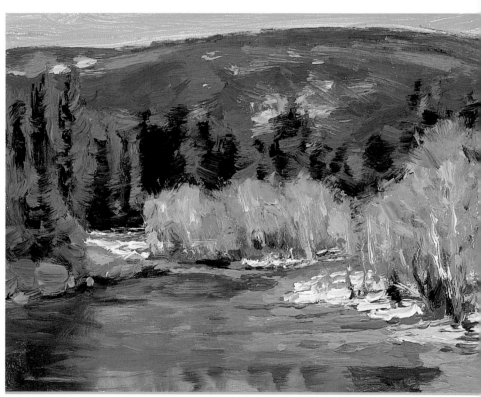

NOVEMBER 19

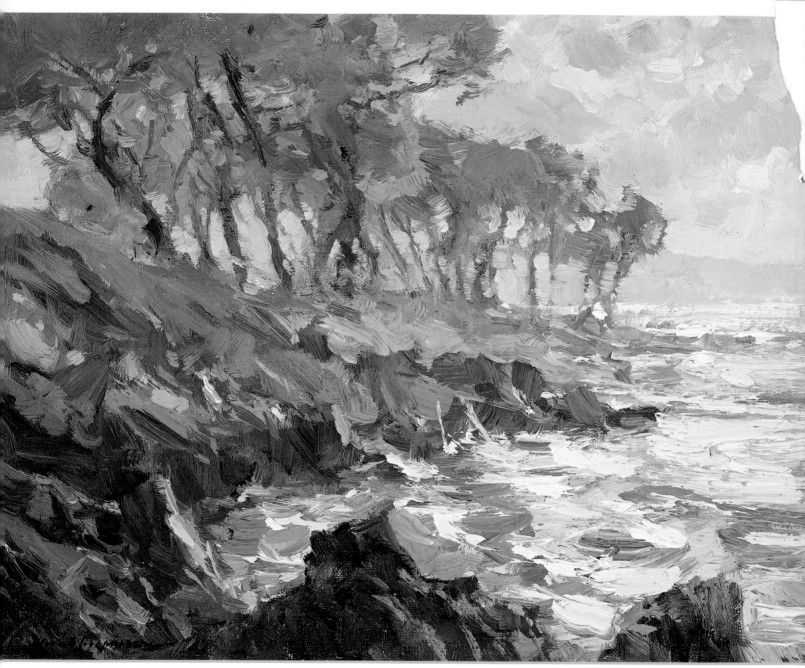

Wailea Shores
11" × 14" (28cm × 36cm)

Twelve years ago, Wanda gave painting a try, and now it has become her passion too. Our joint world has been immensely expanded as a result, and Wanda and I cherish the students and collectors who have become good friends. Where our paint boxes will lead us next is always a mystery.

No "complain-air painting" here.

Aspens of Winter
30" × 36" (76cm × 91cm)

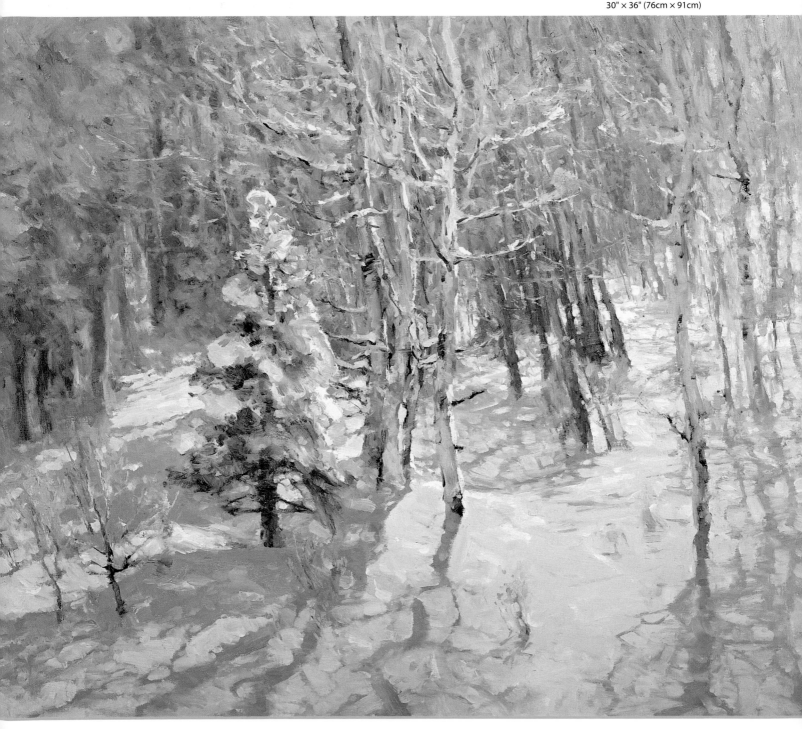

Index

Find instruction and inspiration in these other North Light Books!

Fill Your Oil Paintings With Light and Color

by Kevin D. Macpherson
ISBN-13: 978-1-58180-053-1
ISBN-10: 1-58180-053-3
Paperback, 144 pages, #31615

In his first book, master painter Kevin Macpherson shares his effective approach to capturing nature's glorious colors and luminosity in oils. By following his use of bold, direct brushstrokes and careful composition, you'll learn to work in a loose, painterly style as you create spectacular oil paintings with rich, glowing tones.

A Painter's Guide to Design and Composition

by Margot Schulzke
ISBN-13: 978-1-58180-643-4
ISBN-10: 1-58180-643-4
Hardcover, 144 pages, #33229

Learn the keys to composition from 27 of the world's best living painters! This book breaks composition down to its basics and shows you how artists think as they create. You'll find paintings and inspirational advice from renowned artists such as Albert Handel, Daniel Greene, Bill James and Clark Mitchell, plus nine painting demonstrations encompassing a variety of subjects and mediums.

Painting the Elements:
Weather Effects in Oil, Acrylic and Watercolor

edited by Pam Wissman and Kelly Messerly
ISBN-13: 978-1-58180-887-2
ISBN-10: 1-58180-887-9
Paperback, 192 pages, #Z0275

The most dramatic landscapes come to life because of the artist's ability to render atmosphere. Whether it's painting a crisp autumn day or an overcast morning before a storm, Painting the Elements provides all the step-by-step instruction you need to accurately portray a wide variety of climates and conditions. Over 25 projects by North Light Books' bestselling authors let you learn from a multitude of artistic styles and approaches.

Artist's Digital Photo Reference:
Landscapes

edited by Erin Nevius
ISBN-13: 978-1-58180-901-5
ISBN-10: 1-58180-901-8
Hardcover with two CD-ROMs, 64 pages, #Z0313

Next to the great outdoors, the best source of inspiration for landscape artists is a vivid photograph of the wonders of nature. In this must-have set, you'll find two CD-ROMs packed with a wide selection of high-quality color photos of popular subjects including mountains, oceans and trees, along with a book of step-by-step demonstrations that teach you how to use photographs as reference.

These books and other fine North Light titles are available at your local fine art retailer or bookstore or from online suppliers.